My Journey in 1970 to Maharishi's India

Jonathan Miller

Shikshana Parthika Press
Santoshi Films LLC
c/o Kiva Management LLC
3000 Pearl Street Suite 102
Boulder, CO 80301

contact: jonmillerlaw@gmail.com
shikshanaparthikapress@gmail.com

Library of Congress Control Number: 2014914314

ISBN for print book: 978-0-9906910-0-6
ISBN for e-book: 978-0-9906910-1-3

1. The main category of the book —Photography —Other category.
2. Travel — Other categories 3. Memoir

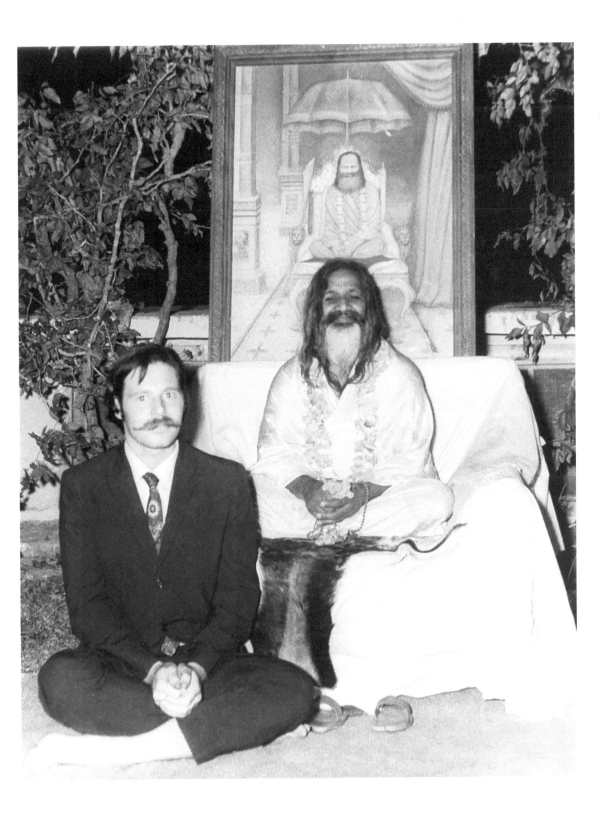

TABLE OF CONTENTS

DEDICATION

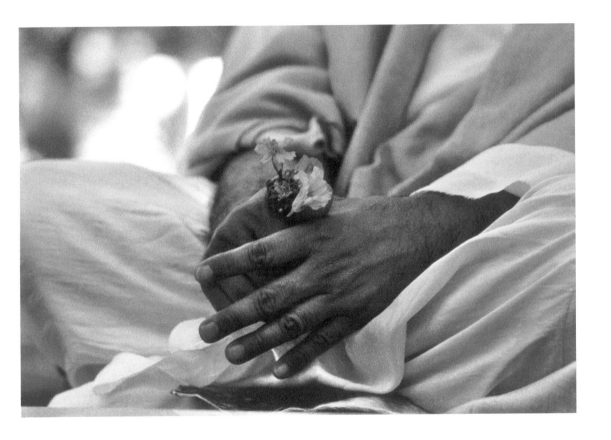

To Maharishi Mahesh Yogi, His beloved master, Guru Dev,
Swami Brahmananda Saraswati Maharaj, Shankaracharya of Jyotir Math,
and to the Holy Tradition of Masters.
To my family, friends, and to all seekers of love, life, truth,
wisdom and joy everywhere.
Deeply felt gratitude to my wife, son, parents, grandparents, siblings.

ACKNOWLEDGEMENTS

Gratitude for eagle-eyes, word-for-word reading, memories,
insights, materials, and encouragement to
Arleen Miller, Rick Archer, Carla Brown, Bill Brunelle, Ken Chawkin,
Fred den Ouden, Henry Eckstein, Therese Gibson, Bill Goldstein,
sharp-eyed Joy Hirshberg, Daniel Jackson, Richard Kaynor, Paul Mason,
Jerry Miller, Susan Seifert, Russell Stamets,
Susan Humphrey Tracy, Ross Winetsky.

A debt of gratitude is due Jerry Jarvis who generously and painstakingly corrected
inaccuracies in the text and graciously provided extensive details
regarding early times with Maharishi and the inception
of the Transcendental Meditation movement.

A debt of gratitude to Julie Kandyba
for her diligent and beautiful book design.

Any inaccuracies are the author's responsibility,
all good came from those and others who inspired and helped.

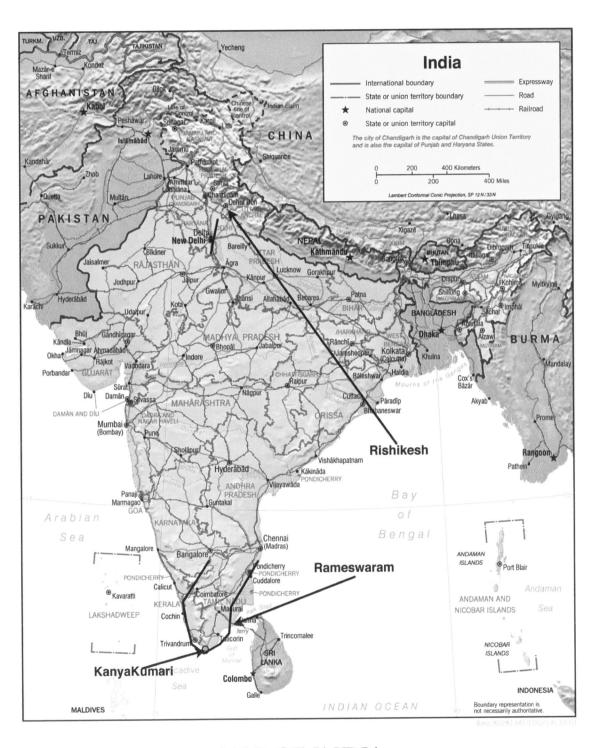

MAP OF INDIA

FOREWORD

In January 1970, Jonathan Miller was one of 177 people from various parts of the world who made the journey to Rishikesh, a venerable pilgrimage town in the foothills of the Himalayas, to study with Maharishi Mahesh Yogi and train to be a teacher of Transcendental Meditation. In succeeding decades, Maharishi would train 40,000 women and men from all parts of the globe to teach the TM technique, in large courses in comfortable Western facilities. Accommodations were more than a bit austere in India, though the lack of Western amenities was more than made up by Maharishi's daily presence.

This delightful book, illustrated with dozens of Miller's own photographs, captures the essence of the experience, from the environment—the Ganges flowing below the hilltop ashram and the monkeys in the trees—to the daily routine of the course, comprising long hours of meditation, study of the science of consciousness, and practical principles and methods of teaching—to Maharishi himself, who held three meetings a day and was a fountain of wisdom and joyfulness. As I was a participant on that course, I can vouch for the absolute authenticity of every aspect of this book.

Additional treats are photos and anecdotes of two great, now legendary saints, "friends" of Maharishi, Tat Wale Baba and Anandamayi Ma, and stories and photos of a trip the author took to South India after the conclusion of the course, retracing Maharishi's steps in the 1950s as he was beginning his worldwide movement. Other photos evoke the memory of local workers around the academy,

building or gardening, sometimes with Maharishi directing the construction and landscaping.

We also see Tibetan monasteries that Jon visited, their colorful prayer flags flying in the breeze—something that was extremely exotic in 1970 but which has become more common as people have become aware of the Tibetan people and their plight at the hands of the Chinese.

Visiting ancient temples (wearing traditional Indian clothing gave him and his travel companions access that other Westerners were denied), eating fiery food, sleeping on the ground on bamboo mats, traveling by bullock cart, Jon Miller experienced an India that only a few intrepid travelers have known. His fine book brings to life the diverse cultures of north and south, and the sounds and sights of India, as well as the pleasure and privilege of studying with a great master teacher.

In the chapters devoted to the actual course in Rishikesh, Miller describes teachings about consciousness and its evolution, and intersperses delightful anecdotes. For example: "*Maharishi loved boat rides, particularly during full moons. One evening, later on during the course, small motor boats were chartered, and we walked down to the Ganges in the dark, and entered open boats. It was lovely to walk down to the Ganges under the full moon.*"

He also shares some interesting reflections. As a lifetime student of science, with degrees in Physics and Sociology and much study of Math, Biology and Ecology (in addition to his law degree), Miller came to believe that "*the religious impulse springs from the same source as the fount of science: the human desire 'to know,' to ponder, investigate, muse, contemplate, understand. This is a universal impulse, transcending culture. There are fundamental impulses in all of life: to live, to seek happiness in all its forms, and perhaps one that is uniquely human—the desire to know—to know what is going on in one's life, to find order, understanding, wisdom, peace or solace. To know oneself.*"

In those early days of Maharishi's global activities, he was entirely accessible, something that became increasingly impossible as his worldwide organization grew. It was relatively easy to get to know him, and to observe his behavior close-up: the experience of being around Maharishi at first was like being around a favored uncle

or grandparent, loving and respectful, but with no barriers. He did not like false displays of formality or require any formulaic behaviors. He always treated others with the utmost respect and warmth.

And this: "*When we went out of the Academy with Maharishi, Hindu devotees would throw themselves at him, touching and kissing his feet, bowing their heads with devotion to the ground. Maharishi did not appear to like this. He said, 'They bow to me, but they don't do what I say.' And then with a laugh, 'They should meditate.'*"

It is my belief that Maharishi's legacy has only just begun to be appreciated. May this book serve to introduce more readers to a great man and a visionary leader, as well as warming the hearts of those who did have the privilege of knowing him.

—Jack Forem
January 6, 2015

INTRODUCTION

To attune himself to the vibration of enlightenment, Maharishi Mahesh Yogi, a young graduate in Physics from the University of Allahabad, devoted himself in service to his Master and Teacher, His Divinity Swami Brahmananda Saraswati Maharaj, Jagadguru, Shankaracharya of Jyotir Math, known as Guru Dev.

After his master passed in 1953, and after living in solitude for almost two years, Maharishi eventually traveled south to Kerala, South India. There he began to teach "A Simple System of Meditation," later called "Transcendental Deep Meditation," to distinguish it from other uses of the word meditation. It is now called the Transcendental Meditation Program.

In 1970, the author traveled to India to study, under Maharishi's guidance, how to teach TM. This book is a historical and personal frame of those moments in time.

Speak the truth, speak the sweet truth"

<div align="right">

—*Maharishi Mahesh Yogi*

</div>

"It is a C-R-I-M-E to speak ill of others"

<div align="right">

—*Maharishi Mahesh Yogi*

</div>

PREFACE

In January, 1970, I traveled to India to study the Transcendental Meditation®* (the TM®) program with His Holiness Maharishi Mahesh Yogi and become a teacher of TM. These are my personal recollections and photographs (resurrected with modern photo-editing). Some of the memories are as clear as yesterday, others have come back to me while writing, talking to friends, and in quiet contemplation.

This book is very personal. Through the filter of time, all memories are delightful. The time and the moments are irreplaceable and very fortunate.

Chapter 1 is a compendium of much of what led me to meditate, to travel to India, and then the first steps of the trip itself. There are subtitled sections for those of a linear mind. This chapter is an introduction; it is longer than the rest of the book and has fewer pictures. Chapter 2 sets the scene of life in Maharishi's Academy in Rishikesh. Chapter 3 comprises pictures and recollections from Maharishi's teachings at the Academy. Chapter 4 touches upon the great saint Sri Tat Wale Baba who lived in a cave in the jungle near the Academy and who was Maharishi's friend. Chapter 5 embraces the great saint Sri Anandamayi Ma, who spoke of Maharishi very warmly when we went to see her and receive her darshan when she appeared at two of her ashrams—one in Dehradun (sometimes called Dehra Dun), and the other, as I recall on the road to the hill station, Mussoorie, a relatively long taxi ride from Rishikesh. In Chapter 6, I share pictures and stories from my time at the Academy and traveling in India after the teacher training course had been completed. This included a trip to Bangalore with Maharishi and then a further journey to Alleppey, Trivandrum, Quilon, Kanyakumari, Rameswaram, and Madurai with Brahmachari Sattyanand, Geoffrey Baker and Fred den Ouden — our traveling at Maharishi's request to accompany Sattyanand to visit the places Maharishi did when he first left Uttarkashi in the Himalayas. Chapter 7 is a post-script and epilogue with some photos from times just subsequent. Enjoy!

* It is now called The Transcendental the WORLD PLAN EXECUTIVE COUNCIL and the MAHARISHI FOUNDATION, LTD. CORPORATION.

THE JOURNEY BEGINS

"Hayam duhkham anagatam.
Avert the danger which has not yet come."
 - Maharishi Mahesh Yogi (from Patanjali, Sanskrit)

A journey begins with intention. Things begin to organize themselves around your intention. Then comes commitment. A commitment is a pure and clear intention running like a mountain stream to your heart. You believe with heart, mind and soul. Then all the gears and machinery of creating your dream are set in motion to fulfill and realize your intention.

Flight to India

THE AUTHOR FIRST HEARS OF MAHARISHI

I first heard of His Holiness Maharishi Mahesh Yogi (Maharishi) in 1962. I saw an advertisement in the Boston Globe with Maharishi's picture and a notice to call a certain telephone number in Cambridge, Massachusetts to secure an invitation. At the age of 14 going on 15, I felt shy about calling and going to a stranger's large house that I later learned was on a shady New England street. Then calling slipped from my mind, but was never forgotten.

Perhaps I had been called. That same night, I went to the old Huntington Avenue YMCA in Boston and in a small basement room listened to the master bluesman Lightnin' Hopkins play for a few lost souls.

DESIRE TO LEARN TO MEDITATE

A few years later, as an admirer of The Beatles, and their brilliance in finding future trends, I read of their travels to India with the same guru, Maharishi. I was intrigued. I believed that the Beatles were in the forefront of a global artistic and cultural metamorphosis. While living in Mill Valley, California, in a cabin in the woods in Forest Knolls, I went to hear Jerry Jarvis talk at Berkeley months after Maharishi had spoken at Harvard University in Cambridge, Massachusetts. Jerry Jarvis was Maharishi's national spokesperson to students as head of SIMS, the Students International Mediation Society; Charlie Lutes was the leader for adults, the head of SRM, the Spiritual Regeneration Movement. Maharishi at a later time recommended that I get to know Charlie Lutes better. Sad to say, I never had that opportunity. Maharishi had remarked that Jerry seemed the youngest of the new teachers, and although he may not have appeared to us students as that young, he made an immediate impression of warmth, wisdom, grace, joy and peace. I have always enjoyed his humor and support.

THE AUTHOR LEARNS TM

One day, shortly thereafter, in my home state of Massachusetts, I was visiting a friend, Richard Shamach (known as Sham) an extraordinary rock-jazz guitarist with the accomplished and loud band, Eden's Children, eventually produced by Bob Thiele of Coltrane and Mingus fame. Sham quietly suggested I learn to medi-

tate with Maharishi's Transcendental Meditation technique. I asked Sham why he wanted to learn to meditate. He said he wanted to be as much like Maharishi as possible.

Jerry Jarvis returned to speak in Cambridge, February, 1968. I recall someone taunting him at an introductory lecture he gave:

"You say that: 'Being comes before thinking. Well, Descartes said, 'I think therefore I am?' How about, 'I think I think, therefore, I am I think?'"

That was pretty good. The audience began to laugh. Jerry replied,

"You think, because you are. Being comes before thinking. That is putting Descartes before des source!" *Sum ergo cogito q.e.d.*

I never did understand how he came up with such a lightning repartee.

After attending the public lectures, and for $35, as a student, I was initiated into the TM technique on February 17, 1968, on a dusky, late winter afternoon in the house in which I might have met Maharishi six years earlier. My teacher was a wisp of a Canadian lady, Merilyn Jest, soft spoken and sparkly. I was taught to meditate for 20 minutes twice a day. I immediately loved the sensation of expansion and peace, and asked whether I could meditate longer? I was given specific instructions in private that comported with Maharishi's teaching at that time for maximum meditation.

I was fortunate. I began to have experiences of profound inner quiet, of relaxation, joy, peace, and transcendence. I did not think that my day-to-day life was ideal. I struggled with my resistance to being a student then at Brandeis, and to finding a comfortable place and purpose in life. But, I found that I could meditate in a very cold room and generate heat or adapt to warmth and not be discomforted. This was an ability that came unbidden and left identically so, not long after. This was not part of the teachings and it simply arose for a time spontaneously and left. I could use this now when I feel chilly.

An experience of precognition

My father invited me to go to the Bahamas with him for a medical conference. I don't remember much of the glitter and glamor except that there was an attractive young woman, approximately my age, with whom I enjoyed talking. We

exchanged phone numbers, there was no email then. On the last day of the conference we were riding an elevator together with her mother. I asked her—is your mother OK? She asked why? I said something seems wrong. Is she sick? She said, No she is fine. We parted our ways to never see each other again but a few days later she did call me in Brookline, and said, "How did you know? My mother is dead! She died of a brain aneurism." I said, "I have no idea. Everything is glowing and the light around her appeared dark (that is, there was an absence of light) even though she otherwise looked fine. I didn't understand and I wondered. I am so sorry." This was a perception about which I had no knowledge or understanding. It came unexpectedly. For this young woman and her family, it was a deep personal tragedy. There is little doubt that that dark-haired girl never wished to converse with me again.

In 1968, although I was practicing meditation, I dropped out of Brandeis; it was a time of social turmoil. I got a job in a bank as a teller in a very busy part of old Boston, while taking night courses at Boston University (no matter how much trouble I had had with being a student, I love to study and to learn), reading Lao Tse and Chinese philosophy, and studying photography. I loved science, specifically physics and math. On breaks in the bank I would read Asian and Western poetry, philosophy, and literature.

As a substitute teller, I was then filling in for other tellers. One day a man came to the bank. I looked at him and thought that he seems like an honest man, a good man. That night, as I settled up, I thought that I was 8 cents over, which was quite good for me, but then it turned out that I was $999.92 under. That was a heart-sinking shock. I immediately reported it. For the next few days the bank examiner and I went through all my transactions. He was warm and easy to work with. We isolated all my large transactions, and discovered that the teller that I was subbing for had mistakenly tied some bundles of large bills in a non-standard form: $2000 rather than $1000 packets. Eventually the bank examiner called each of those few with whom I had had large transactions, and the very man I had felt for (he was getting money for his child's summer camp) came forward and admitted that he had received an extra thousand dollars and had left it in his safe deposit box in that bank. He was an honest man and I had inadvertently tested him and myself sorely.

READING EASTERN PHILOSOPHY IN NIGHT SCHOOL

At the time that I was first reading the Tao, I also read *Autobiography of a Yogi* and the *Three Pillars of Zen*. Much later in India (2 years) I was changing planes in Hyderabad with about a dozen people with Maharishi on the way to Bangalore. Maharishi noticed that one of the group was reading *Autobiography of a Yogi*. I said, "Why would you bring flowers to the garden?" Maharishi laughed loudly and said: "Yogananda was very good, a great saint; he had the best methods [for enlightenment] before TM. Yogananda called his methods the airplane technique and now we are using the jet technique." I have loved that book since first reading it in 1968 and have read it dozens of times, although not around Maharishi.

MY PSYCHO-PHYSIOLOGY BEGINS TO CHANGE

In the spring of 1968, just after learning to meditate, I noticed my reaction times changing. Previously I had been very clumsy, and confessed to leaving a wake of destruction in the kitchen and everywhere else. Now, when I dropped a dish or implement, I caught it in midair, ambidextrously, before it landed or broke. This is a lesson of not letting your mind interfere with your coordination. I still occasionally drop things.

TM STUDIES BEGIN IN AUGUST 1968 WITH MAHARISHI

In the summer of 1968, I traveled to attend a TM residence course in Squaw Valley, California, for the month of August. Maharishi was to be there. I bought a used white VW bug for about $500 with a sunroof to drive there. The next day, I saw a young man hitchhiking in Alston along my favorite, well-worn route from Harvard Square to Brookline, one that I had driven and walked countless times, and offered him a lift. I said without thinking, "Are you going to California?" He said, "How did you know?" I said, "I didn't know but I am driving there at the end of July and have no one to help drive." He signed up and helped with driving and expenses. We enjoyed seeing Chicago suburbs and we stopped in Wisconsin to visit his family. There were magnificent waving corn fields (although New England corn tasted better), dairy cows and cheese. We got to California quite quickly. I dropped him off in Berkeley and visited a dear friend for a day, and then hastened

to Squaw Valley, near Lake Tahoe, in the Sierra Nevada mountain range.

The TM meditation group had taken over the Olympic Village of the 1960 Winter Olympics. The high mountain air was cold and the sunlight as crisp and bright as only in the California mountains. We were assigned dorm rooms in the Olympic quarters. There were about 750 people attending. Most of us were enthusiastic young people but there were mature families and some celebrities. One night, I recall standing near the rear doors with The Doors (sans Jim Morrison) with their Porsches nearby. The course participants ate in the cafeterias and attended talks in one large auditorium in which Maharishi sat on a stage with a picture of his teacher, Guru Dev, on an easel near him, each adorned with flowers.

I learned that the term "Maharishi" was a title that meant great holy sage or seer that was bestowed upon him after he began teaching. In 1955 he had been called Bal-Brahmachari Mahesh Yogi of Uttarkashi, Himalayas (*see Beacon Light of the Himalayas*) when he began to teach in South India.

Maharishi originally called his technique "A Simple System of Meditation." Later it evolved to being called "Transcendental Deep Meditation." Eventually Maharishi shortened it to the "Transcendental Meditation Technique." Maharishi explained that a "rishi" holds the knowledge but does not have responsibility of teaching it to the world. A Maharishi has the responsibility of teaching it, making it available to the world. Thus the title is fitting. Maharishi named his technique Transcendental Meditation to educate the world about the real meaning of meditation.*

Maharishi had moved to Uttarkashi after his master, Guru Dev, had passed away in 1953, to live a life of silence and meditation. Maharishi once said the title 'Maharishi' was not exactly correct but it was easier to let it stay than to explain how to correct it. Perhaps the proper title would be Brahmarishi—seer of the Absolute. This mystery may remain.

Maharishi's master, Guru Dev, had left home at the tender age of nine to seek enlightenment. He traveled by foot to Hardwar (also spelled Haridwar), and then to Rishikesh, also on the River Ganges. Eventually he found a teacher in the Himalayan village of Uttarkashi.

* Explanation courtesy of Jerry Jarvis.

Born Mahesh Prasad Varma, Mahesh was Maharishi's given name; his master Guru Dev had told him to keep it. In India it is typical to have names based on names of Gods and Mahesh is a name for Lord Shiva (the "Auspicious One") or Mahadev ("Great God). Yogi is a title or status indicating that he was a practitioner of and had achieved union (yoga) with the Absolute, with pure Being, the state of enlightenment.

He was formally referred to as His Holiness Maharishi Mahesh Yogi. Maharishi defined a saint as one who does no harm. That state of harmlessness is a consequence of being in tune with all the laws of nature, of achieving the state of union with Pure Consciousness. In India, the term "ji" is appended to a name, indicating respect. For example, a Hindu addressing Maharishi directly might say, "Maharishiji". Loosely translated that might mean Maharishi, sir. Maharishi took no notice of honorifics such as this and no Westerner gained any favor or goodwill by false cultural displays of respect. In fact, the experience of being around Maharishi at first was like being around a favored uncle or grandparent, loving and respectful, but with no barriers. He did not like false displays of formality or require any formulaic behaviors. He always treated others with the utmost respect and warmth. This may be the state of Unity.

A couple of years later I found myself alone in a darkened hotel room with Maharishi sitting quietly, for a short period of time, while traveling from India. Then, the enormous silence and expansiveness was palpable. This was a bit frightening: each of my private thoughts sounded like a shout into the night.

MAHARISHI'S INTRODUCTION
TO STATES OF CONSCIOUSNESS

One of Maharishi's messages was that one experiences different states of consciousness. One is either asleep at which time one is not conscious (the null set of consciousness), or awake, a state in which one experiences the objective universe shared with others, or in a dream state, a state in which one experiences a world of one's own creation. However there are other states of consciousness.

A fourth state, *Turiya* (meaning "Fourth") is a state of consciousness in which one is awake, fully awake, in oneself, with no appreciation of external or internal

occurrences. This is the state of just being awake—being awake in your Self. Pure Consciousness. Silence. In this state, the body is more restful, the breathing slows or stops intermittently, the time between breaths becomes longer, and one emerges rejuvenated, rested, alert. Maharishi called this state "restful alertness." He said that others had called this state samadhi, nirvana, sartori, and other terms denoting a kind of enlightenment. It is not the goal. A consequence of the Transcendental Meditation technique is to dip in and out of this state several times during practice.

At that time, the philosophy of Existentialism was the rage on campuses. Existentialism had wonderful exponents in writers such as Sartre and Camus and provided a philosophy of living well, without requiring answers to ultimate questions about the meaning or nature of life. Life was ever-changing, never constant, and life was what you made of it. Life was flowing downstream so you had to make a leap of faith and steer the craft of your life.

Maharishi explained that this was a very good philosophy—to make your life into something worthwhile despite its ever-changing nature. However, he said, "The word 'EVER!' "—the fact that life was ever-changing was a constant in itself and that was because the ever-changing values of life rested upon the underlying unchanging universal nature of life. The Absolute value of life is the constant while everything else is changing. The nature of the Absolute is unchanging Pure Consciousness. Everything else changes.

What is in us that is the same when we are 20 or 66? Our own internal nature, our deepest identity with absolute value of life is unchanging, and provides continuity to our life. Pure Consciousness is unchanging. Everything else changes. The experience of restful alertness alone is not the end goal. You have to live your life. The prescription of meditation was to practice 20 minutes (I liked longer) and then be active, to do useful things during the day. Meditate again in the evening, and then have an evening's activity before bed. This regime brings the unchanging value of life into the ever-changing experience of living. This brings the Fifth state of consciousness.

Maharishi was always very practical. He also made us laugh repeatedly during each talk. For example he was asked, What should you eat? He answered, Whatever your mother cooks you. How much should you sleep? Early to bed and early to rise.

One simple prescription: Meditate and act.

Maharishi explained that the techniques of yoga were taught to the kings, the rulers, the landowners and warriors in ancient times in India. The most responsible members of society required the greatest power and stability. Practical.

The next significant topic was that there are higher states of consciousness beyond the Fourth State of Consciousness. This was logical. Higher states comprised the combination of being established in the Fourth State of Consciousness, Pure-Consciousness, *Turiya*, all the time, while at the same time experiencing waking or dreaming or sleeping states. Maharishi explained that this combination of Pure Consciousness along with the other three is called the Fifth State of Consciousness, Cosmic Consciousness—since one is aware of the unbounded nature of life, of one's own consciousness, while, at that same time experiencing waking, dreaming or sleeping consciousness. This constant Pure Consciousness, experienced along with the other three states, provides comfort and stability in life as well as the automatic ability to act in accordance with the laws of nature. Cosmic Consciousness, "CC", provides a life raft of stability and comfort to navigate the tumultuous seas of life. However, the term "Laws of Nature" is one of those delightfully ambiguous terms that appears to be simple, until one attempts to contemplate its meaning.

Maharishi described a Sixth State of Consciousness, called God Consciousness, and a Seventh State which is not a state at all but rather the Unity of all Consciousness. Not enough was said then about the Sixth State except that one could directly perceive the brushstrokes of the Painter, the Creator, the Architect of creation, as the impulses and mechanics of the creation of the ever-changing universe.

The Seventh State was that fabled state of consciousness in which all boundaries are removed and one directly apprehends the meaning of the Upanishadic statement: "I am That; Thou art That; all this is That." The term 'states of consciousness' is only used to explain progress. Maharishi called this the Supreme State of Knowledge. It is said in the Upanishads that in this state, there is no fear, no separation. Maharishi has said that it is unfortunate, a loss, if every person does not live in this life on earth in this state of consciousness.

Laying out the steps of the development of consciousness, in simple, logical,

teachable terms is one of Maharishi's greatest contributions. Another of his great contributions is the series of techniques designed to allow every person to directly grow into the experience of higher states of consciousness. That knowledge and experience of higher states of consciousness provides a framework for an understanding of the development of consciousness and an explanation of how some people remain buoyant, stable and creative for their lives, develop astonishing states of intuition and insight, and great worldly success.

Others who have intuitive abilities without understanding can be overpowered by their experiences and remain unfulfilled. But, without the growth of Pure Consciousness, Cosmic Consciousness, one is tossed about on the waves of life without a flotation device. Maharishi admonished: "Capture the fort [of Pure Consciousness]", and live a fulfilled life. Maharishi promoted living 200% of life: a life of inner Pure Consciousness and outer success and joy.

Another analogy that Maharishi used for enlightenment was: "Mother is at home." The warmly-colored image of hearth and home is brought to mind. The state of enlightenment brings comfort and stability. When you are awake in yourself you are at home. Perhaps if you are in GC—God Consciousness, mother is there?

Maharishi was asked whether the growth of Cosmic Consciousness was gradual or a click. He replied, "It's a gradual click." This was hilarious. But the meaning was that although it came on gradually, when Cosmic Consciousness appeared in full, there is a profound change of state. The whole is greater than the sum of the parts. His message to the world that summer in Squaw Valley was meditate and act: live a fulfilled life of 200%—all inner and outer values, and then spread joy, happiness and success.

INSIGHT: METAPHOR OR EXPERIENCE?
THAT IS ALWAYS THE QUESTION.

Toward the end of the course I went to Truckee, Nevada to prepare my VW bug for the road home. While the mechanics were changing the oil and checking the vehicle, I sat on the ground by the Truckee River on the sand and the dirt, and practiced the yoga asanas (postures), which we did before practicing meditation.

As I did a shoulder stand, I saw a golden light effuse over the sky and the visual hemisphere—the gold light turned the blue sky into an emerald color; the whole world was golden. As I lowered my legs back to the ground, the vision eventually faded. A tiny bit of it has never left.

Maharishi had said the world is as you are. If you wear rose-colored glasses you live in a rose-colored world. If you wear golden glasses—then that world is gold for you. Was this literal description or metaphor? Something to think about with regard to all the myths and metaphors.

As Maharishi talked in the lecture hall to all 750 people, his eyes would flit around the room, sparkling like diamonds, engaging each person. It seemed as if he were looking at and through each of us. One night I thought I saw the portrait of his teacher Guru Dev pulse with a green halo.

MISCELLANEOUS TOPICS SUCH AS REINCARNATION AND MURDER

During the Squaw Valley course, Maharishi indulged the audience with humorous tales of reincarnation. Maharishi made light of a serious topic, one that is very troubling to western science and existentialism. The trouble with science is that as with any belief system, beliefs become sufficiently ingrained and positions vested such that it takes a generation to replace old science with new. This is not an original thought. Recent studies and articles by surgeons, too, report that consciousness and perception persist after NDEs (near death experiences) and death experiences, which rather begs the question.

Maharishi: "Where you go depends on your last thought."

Question: "What if your last thought is cat?"

Maharishi: "Then that's it!" Roars of laughter. "But whether you end up in an alley or on someone's couch—that is determined by your actions. The word karma means actions. As you sow, so shall you reap."

Question: "What if your last thought is Maharishi?" Loud laughter.

Maharishi: "Then you come back and enlighten the world over and over again!"

Another question, "What if a murderer becomes enlightened?"

Maharishi: "Then only kill people who need to be killed."

Of course this speaks to our patriots and war heroes and to others, who protect society.

I APPLY TO STUDY IN INDIA

Toward the end of the course, Maharishi held personal interviews—one by one—for those of us applying to attend his teacher-training meditation course in India. There were several scheduled: Fall 1968 (a celebrity course as it turned out), some in 1969, and finally January 1970. While I was waiting to be interviewed personally by Maharishi, meditating in a grove of trees in the Sierras, a bird landed on my shoulder. I was quite startled and so was the bird. When I spoke to Maharishi, I was told that I would be accepted to teacher training. He said, "You are young so you will come January 1970." He wrote down January 1970 on an index card that I had filled out with my name and handed it to Jerry Jarvis. I would have just turned 22 then.

I drove back to Massachusetts. A friend accompanied me part of the way. While attending classes, working, and biding time, I frequented the TM center at 27 Concord Avenue in Cambridge. Our group of friends would take turns giving introductory talks on the TM practice at local campuses and venues and in the TM center, explaining the values of adding the Transcendental Meditation practice to daily life as we had been taught in Squaw Valley. We were certified to check people's TM practice to ensure that it was effortless and easy, but not to teach.

We got to know a number of wonderful people. Jerry Jarvis, who has a remarkable sense of humor and joy would pass through on occassion. Jack Forem and Phil Goldberg, now well-known authors, Joe Clarke, a fire and a light, who passed away too young in a small-plane crash a few years later, Charlie Donahue, a philosophy grad student (now professor) with a lovely, facile, enthusiastic mind, Prudence Farrow, my dear friend who is now a filmmaker and married to Al Bruns, both Sanskrit scholars. Another one of our dear friends was an elderly lady, Selena, who had gifts: she would see things that none of us could: things that were not evident to others. It was a natural gift. She was full of joy, humor and charm. She once told us that behind the fireplace at 27 Concord Ave was an antique rifle. And so there

was. She explained that this building had been part of the underground railroad. It turned out that there were hidden rooms in the basement.

Many years later I would have the good fortune to be in Rome, while assisting with the TM teacher training course at Fiuggi Fonte, Italy, at a location immortalized by Fellini in the movie 8¹/₂. Selena was a student on the course. With her, and in the company of brilliant dear friend Elliot Abravanel, possessor of one of the quickest, deepest and wittiest of minds, Selena said: "Do you hear them?" We said, "What? Who?" "The lions, of course!" And as we turned the corner, there was The Coliseum. We couldn't hear them.

The TM center in Cambridge later moved to 33 Garden Street, just around the corner from Concord Ave. Approximately five years later, having finished my first college degree, I had the honor and pleasure of directing that TM center for several months.

Travel to India begins in January 1970

A quest does not count as a quest if there are not innumerable and nearly insurmountable obstacles. We were on a quest for enlightenment. How could the journey be easy?

We had been urged to fly to Los Angeles and join a 'round-the-world' flight itinerary. Instead, the day after a New Year's party in Newton at the home of a dear friend with memories harkening back to high school escapades, we departed for India on January 2nd, 1970. A small group of us sought out bargain flights and determined to travel together. We flew to New York and immediately our flight for Frankenfurt was delayed due to mechanical problems. We were ensconced in a seedy New York airport hotel for the evening. The next day my seat mate on the Icelandic Air flight to Europe was dear friend Prudence Bruns.

I remember seeing the Arctic light as we stopped to refuel in Iceland. We were scheduled to change planes in Europe but there was a blizzard blanketing the continent. Paris airport was closed. We were diverted to Luxembourg, and then to Brussels. We spent several days looking for new flights, arguing with airline clerks. The women in the group wisely chose to pay for a connection to Frankfurt, but after the others had rescheduled, my companion Bill Brunelle recalls time in Lux-

embourg, Brussels, and Frankfurt. I recall spending days drinking hot chocolate, weathering the blizzards, and trying to reschedule our flight to India through arguments with airline personnel. In those halcyon days, one could trade tickets between airlines and airlines were sometimes kinder to stranded passengers.

While en route to see Maharishi, emotions often get heightened. We were in a cheerful state of concerned anxiety, worried that we would miss the beginning of our scheduled teacher training course, and that others whether on the around-the-world flight or the bifurcated and displaced schedules would arrive well before us.

Eventually we were able to arrange booking on a flight to Cairo, on Egypt Air. It was a long flight. We arrived at dusk and were asked to debark. As we descended the stairs we noticed the Egyptian Army loitering nearby with machine guns lazily pointed at the ground near us. As I walked down the gangplank, dear friend Bill (who is an astonishingly good magician, once a disciple of the Great [Tony] Slydini) leaned over from above and said in a voice which sounded like a stage whisper: "Don't worry, you don't look Jewish!" In retrospect that was hilarious, but at the time, deeply concerning. I held a poker face as best I could, and kept walking. As we passed through customs, it was Bill's passport that was confiscated, mine promptly returned. Later all of our passports were confiscated and after much arguing and threats of calls to the American Embassy, returned to us.

We were then warmly greeted by the clerks at the Cairo airport hotel and invited to take a tour of the Pyramids by night. We were told we couldn't leave for a week. We mused whether our delay was manufactured or co-incidental. We learned that there was a group of Chinese citizens who had already been delayed a week, and now it was our turn to be wait-listed.

As tempting was the tour of the Pyramids at night, something I still muse about, we were more concerned about missing an unknown and heretofore unscheduled outbound departure. I did have some thoughts about being Jewish-American in Cairo, and judiciously decided to forbear the Pyramids and one-pointedly await a chance for departure. We had, as I recall, nice rooms in some kind of airport hotel, and we waited by the scheduling desk, barely able to sleep, bent on reaching our destination of India and Rishikesh as soon as possible.

After much arguing and gentle firmness, we embarked the next day on a

flight to Abu Dhabi. This flight was a different animal. It was on an African airline and the aisles were filled with turbaned families, crying babies, drunken English sailors and oil workers, the airplane filled with noise, confusion, and revelry. The oil workers' shabby clothing contrasted with the brilliant reds and oranges of African garb. A group of drunken English sailors entertained themselves with me by asking: "So, are you going to India for Enlightenment?" deeply slurring the words. I said, "Yes!" We had a good laugh together.

We changed planes to a USSR flight, night-bound from Africa over Asia to Bombay. At that time the route was determined by politics, but the ambience by culture. The flight attendants were laughing, beautiful, plump, blonde, Russian ladies. They would prance into the cockpit with bottles of vodka. We heard singing. In Russian. There was revelry. Everyone on board, pilots, flight attendants and passengers, was happy and laughing.

The next day, the flight landed in Bombay. I worked my way into a back office of the immigration department and stated that we were on our way to Ma-

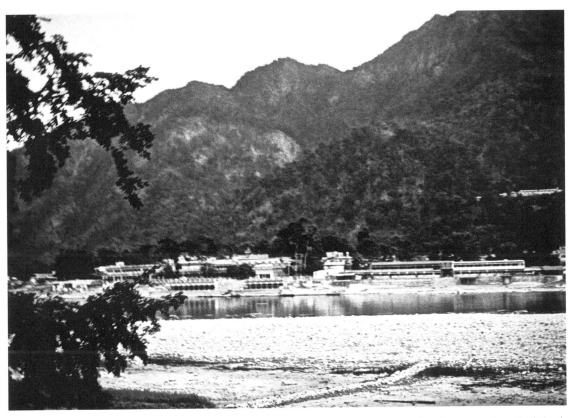

Looking east from Rishikesh

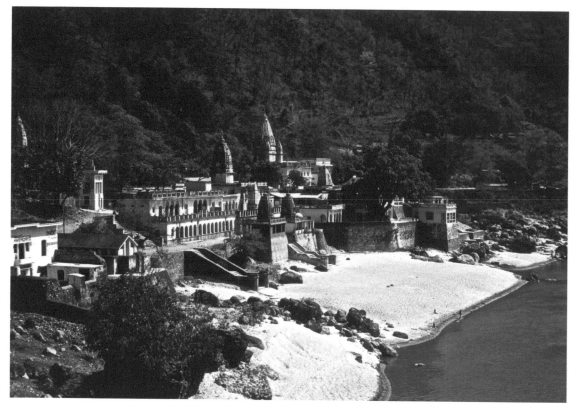

Swargashram in 1970—"Heavenly Ashram"

harishi's Academy in the Himalayas to study meditation. I had told the truth to the drunken Englishmen and there was no reason not to tell the truth here in Mother India, the home of the Veda. One of the clerks said, "I know of Maharishi, he is a very great saint, please be welcomed to India." He stamped our passports and ushered us through into a new and unknown, ancient world.

Without delay and without a glimmer of the scenery of Bombay, we booked a domestic flight to New Delhi. In New Delhi we were to be ensconced in a comfortable hotel, the appointed meeting place for course participants. I remember the contrasts between the impoverished on the streets and the fine hotels and restaurants. We did little exploring. New Delhi was daunting and we were concerned that through our delays, we had missed the inauguration of our course. We drank freshly squeezed sugar cane juice and hot chai's on the street, we could have eaten fine vegetarian meals, but bartered with taxi drivers and acclimatized as if a fog was lifting.

At that time Bill Brunelle and I concocted one of the dumbest plans I have

ever conceived. We found a willing taxi driver, driving the Ambassador car, pretty much the only taxi, let alone auto, made in India at that time, and offered him an outrageous sum of money after enthusiastic bargaining with another sum, perhaps $20, if we got to Rishikesh in four hours. The dollar was strong against the rupee then and that sum was reasonable for us. But the results were astounding.

We knew that Rishikesh was only about 150 miles. We had no idea how reckless this arrangement was. We were concerned about being stranded. As it turned out, I did travel from New Delhi to Rishikesh and back several times that year, and one time, the trip took four days. We saw no Westerners.

Instead, through our weary, sleepy, and then horrified eyes, we saw bullock carts, sometimes with the drivers asleep across the backs of the bullocks, laying perpendicular to the direction of motion, whole families in wagons, bicycles, jeeps, dark green army vehicles, large lorries, pedestrians in multi-colored garbs, all seemingly chaotic. No one appeared to be injured, no accidents were witnessed. It seemed that all were coming from all directions on all parts of the road—apparently right at us. Everyone was driving on whatever side of the road was expedient or suited them at that moment. In some ways it reminded me of traffic in Boston or New York, my proving grounds, but the difference was that although the chaos and likelihood of death appeared to be exponentially far greater, there did not appear to be animosity evident between drivers, pedestrians, bicyclists and animal drovers. In New York and Boston the hostility was palpable. Here it was gentle, disorganized yet deadly. The warmth was reassuring, but that did not ameliorate my feeling of imminent death.

There must have been a paucity of waste facilities and rest rooms, since people appeared to be relieving themselves by the side of, and in the middle of, the road. Later, I recalled Paul McCartney had penned the Beatles song, *Why Don't We Do It In The Road*, I suspected that he and I shared the vision that was his inspiration.

From time to time my eyes would close from fatigue of travel or abject terror. We passed through arid and agricultural countryside and small villages. The traffic began to thin. The air became cooler, cleaner. We ascended towards the foothills of the Himalayas. We saw signs for Hardwar—the fabled pilgrimage city. Pictures of

sadhus, saints and elephants were recalled from books who would parade from time to time during the great religious festivals. In the far distance, we saw glimpses of the high Himalayas, snow-packed peaks and forested hills. The road climbed in the valley of the holy Ganges River.

On this now lonely highway, another taxi came up beside us, trying to wave us down and make us pull over. Bill and I were suspicious that as Westerners we would be easy marks for a scam, or even in danger. This was our Western, perhaps East-Coast, heritage.

Our driver had planned to take the cut-off for Hardwar along a jungle road to Maharishi's Academy. The other driver was vehement that we not go that way. He appeared harmless. We did pull over to find out what he had to say. The other driver stated: "Maharishi has sent me. The bridge in Hardwar is out. You must come with me." That was astonishing. No one could know where we were, or that we were there.

Up to this point, Bill and I recall the same circumstance. My memory is unclear about what exactly followed. I thought we might have switched cabs. The driver explained that Maharishi had told him where to find us.

I thought we paid our driver, tip included, put our belongings in the other cab, and sent our worthy driver on his way home. Bill thinks not. He thinks we stayed with our cab and the other followed. Bill is probably right.

We were driven to the town of Rishikesh on the Ganges where there is a footbridge that extends over the wide river from the secular side to the side where there are ashrams, the hills and the jungle. This was the Laxshmanjula (Laxman Jhula) footbridge. The ashram on the other side was called Swargashram, the ashram at the gates of heaven.

I carried one moderately large suiter, and an old U.S. Army green canvas gas mask bag which I had purchased in a surplus store in which I hid my Pentax 35mm camera, three lenses, film in an x-ray proof bag, a light meter and a few other valuables. It always hung over my shoulders in front of me; I kept an elbow over it, and took it everywhere with no problems.

We were told that this section of the Ganges had fish, tame trout, since no one caught or ate fish. As we crossed the bridge on foot, in the late afternoon

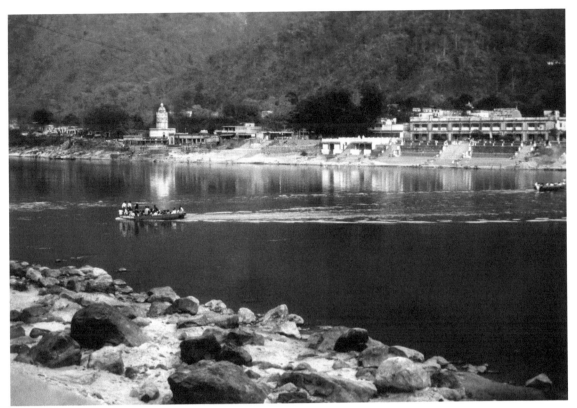

sun, we saw gleaming ashrams, sadhus, mendicants, in their orange and white robes, and cows.

We passed over the bridge, walked down the narrow dirt street by the river, looking in doorways. People in ashrams offered us places to stay and eat. A car was there waiting to take us the relatively short distance along the dirt road by the Ganges, up to Maharishi's Academy, Dhyan Vidya Peeth, the Academy of Meditation.

We were home yet still engulfed with the fear that we had missed the convocation, the beginning of our course. Instead, we were alone. No one else had arrived. Maharishi took silence from New Year's until his birthday, January 12. He was ensconced in his house. There were permanent residents, including the gracious Bevan Morris, then a young surfer from Australia, whom Maharishi had invited to stay and live there, some brahmacharis (unmarried students, mostly Indian, who were disciples of Maharishi), a few Westerners such as John Steinbeck, Jr., who had driven his motorcycle to India from Vietnam, a few workmen building new residences, called puris, named after the Indian puffy bread, and us. Our classmates would not arrive for three days.

Sunset from the Academy across the Ganges

DHYAN VIDYA PEETH— MAHARISHI'S ACADEMY OF MEDITATION

"The purpose of life is the expansion of happiness."
- Maharishi Mahesh Yogi

It's easy to rise early in Rishikesh. Early in the morning, nature wakes, just before the sunrise over the mountains in the East. Birds chirp, monkeys chatter. The chariot of the golden sun is drawn across the sky by seven galloping steeds, each of the seven representing one of the seven colors of the rainbow.

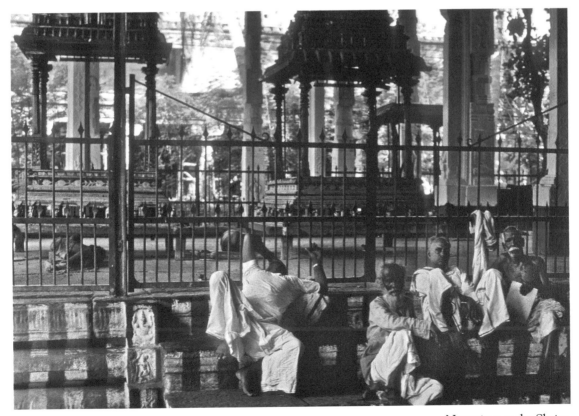

Noontime at the Shrine

Maharishi's cottage

We found that Maharishi's Academy, Dhyan Vidya Peeth, the "Academy of Meditation," was quiet, essentially, because we were the first to arrive. We made excursions to neighboring temples, towns and spots to visit.

On the grounds, monkeys were screeching during daylight hours. They would make a racket. There were reputed to be elephants, tigers, and other wild animals outside the Academy walls. One friend told me he stepped over a log the size of a small tree trunk, and then the log slithered away.

It was also rumored that there were cobras in the environs but that Sri Tat Wale Baba—a great saint who lived nearby in a cave—had made friends with the cobras and their King and had come to an agreement that no human would be bitten. It was said that Tat Wale Baba had said in Hindi: "Snakes have heart."

The monkeys of North India include the rhesus macaque (M. *mulatta*) monkeys. They are inquisitive, intelligent, and can be dangerous. We were warned that they might throw things at you from the trees, like coconuts or poop. They could carry diseases such as herpes and rabies. And they were adorable to look at. At that time, they caused no trouble. Recently they have become bolder in their interac-

tions with humans. Another family of monkeys, called the langur, or Colobine, seemed more refined and gentler, more genteel, but were less in evidence.

Nearby there was a village with the requisite temple. It's lovely and a remarkable observation about human nature that all over the world religious buildings are found in virtually every community—whether a church in the English countryside or a temple in Bali or in India. There is a religious impulse which is compelling and imperative. In my thoughts that religious impulse springs from the same source as the fount of science: the human desire "to know", to ponder, investigate, muse, contemplate, understand. This is a universal impulse, transcending culture.

There are fundamental impulses in all of life: to live, to seek happiness in all its forms, and perhaps one that is uniquely human—the desire to know—to know what is going on in one's life, to find order, understanding, wisdom, peace or solace. To know oneself. We humans want an eternal context. One that is unchanging, transcendent, not transmutable, nor evanescent. It's said that only by recognizing the unity of all consciousness can one overcome the fear and uncertainty of life. There is no one really good word to explain a direct understanding: Intuition? In

Sunset over the Ganges

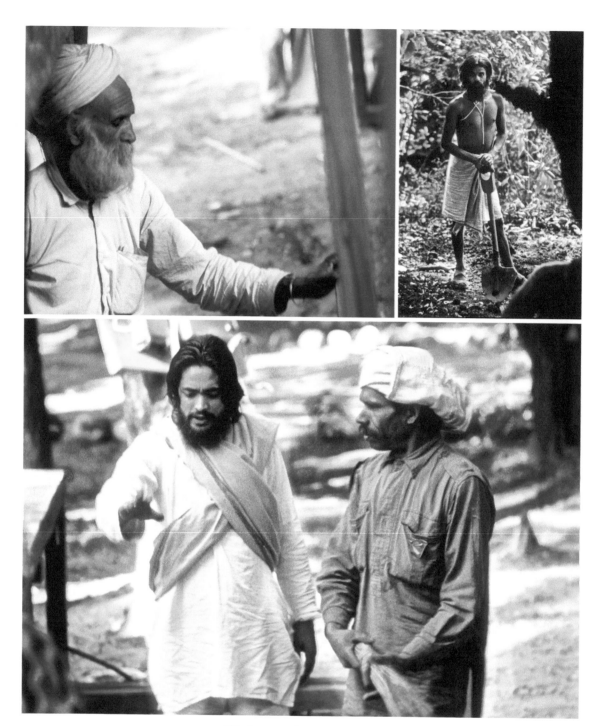

Work around the Academy

Upper left: A skilled carpenter.
Upper right: A fine young man invested with the thread.
Bottom: A Brahmachari instructing a worker how to effect his instructions.

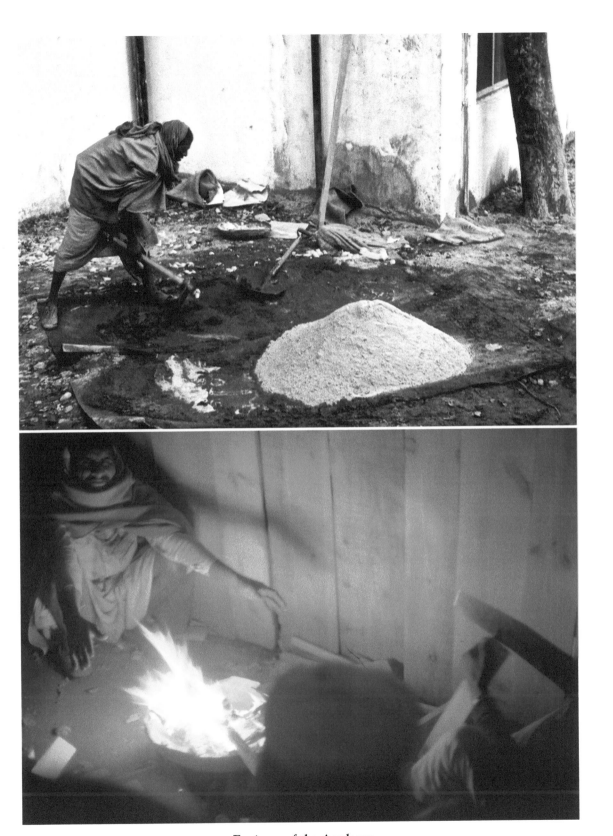

Environs of the Academy

Top: Worker mixing concrete.
Bottom: Workers' evening fire.

sight? Apprehension? Perception? Cognition? Recognition? I like to think that the mystical tradition is one in which one directly knows through perception. The word mysticism in that sense could be quite misleading, since direct perception is not any more mysterious than experiencing or learning, although the mechanism may be different. I would commend reading William James. There is a fundamental impulse to know oneself that is the precursor to inquisitiveness.

One of the beauties of practicing this meditation, TM, is that one can learn it essentially free of larger context. The greatest insights come unasked for and un-expectedly.

Naively innocent of the customs, context, and mores of India, my friends and I found ourselves in humorous trouble from time to time. Indian tailors came to visit the academy and the prices for clothing were quite reasonable for western-ers. We had tailors fashion for us loose pants and shirts, sometimes called punjabis, in a myriad of colors—blues and oranges. We had full-length robes made. Nobody seemed to care. I am still not sure how many customs we trampled. Why would we have robes like medieval mendicants? Is orange verboten? Maharishi took no no-tice and appeared not to care.

When we went out of the Academy with Maharishi, Hindu devotees and people would throw themselves at him, touching and kissing his feet, bowing their heads with devotion to the ground. Maharishi did not appear to like this. He said, "They bow to me, but they don't do what I say." And then with a laugh, "They should meditate."

Maharishi said that he went to the West because people did what he taught. He would use a scientific approach to prove the value of enlightenment to Indians through the West.

Not to forget that his master, Guru Dev, sent him back to school to earn a degree in Physics at the University of Allahabad. The Indian college degree is the equivalent of a U.S. Master's degree. Once in conversation with Brahmachari Nandkishore, I said: "Maharishi is not only enlightened, but brilliant." Nandk-ishore opined: "Maharishi is enlightened, *because* he is brilliant."

One has to be willing to discard one's worn understandings of life, renew and reform them, when they do not comport with one's experiences. As Lao Tse

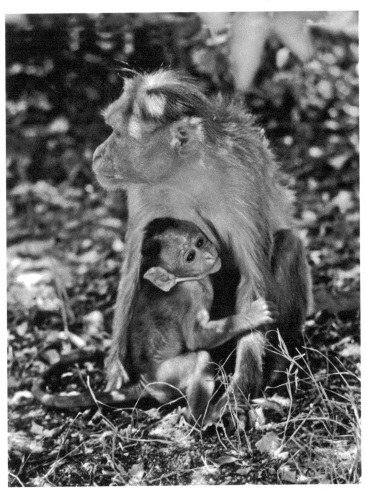

Nearby Sights
Top: Monkey mom and baby.
Bottom: Family with bicycles.

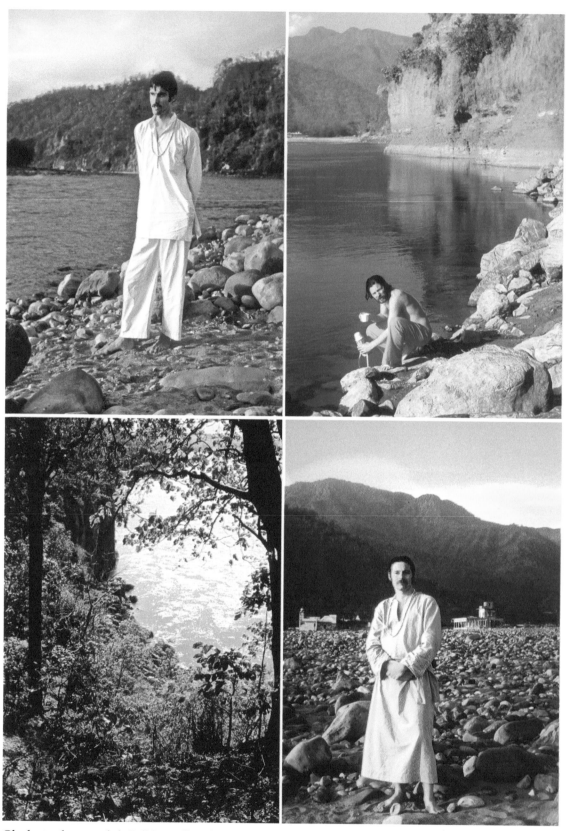

Clockwise from top left: Bill Brunelle, The author at the Ganges, the author in robes, the swimming hole

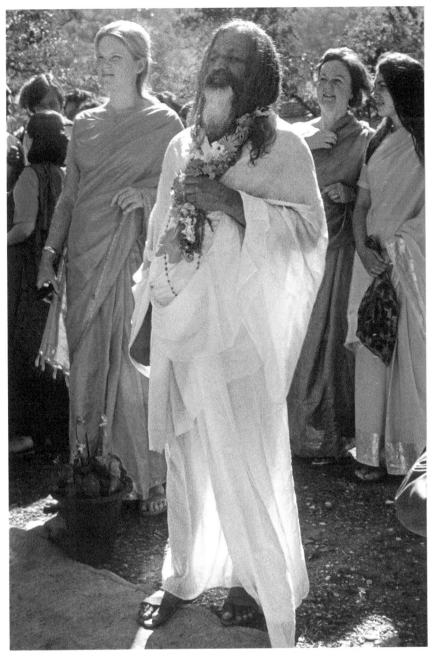

Maharishi with Jane Hopson and others standing nearby

(and George Harrison) said, you can know all things on earth without looking out of your window. "If the doors of perception were cleansed every thing would appear to man as it is, Infinite. For man has closed himself up, till he sees all things thro' narrow chinks of his cavern." (William Blake, *The Marriage of Heaven and Hell*.) I once learned that the original Aramaic word (as found in Job) for "repent" literally translates as "change one's point of view." So keep meditating, cleansing the windows of perception, and changing your point of view.

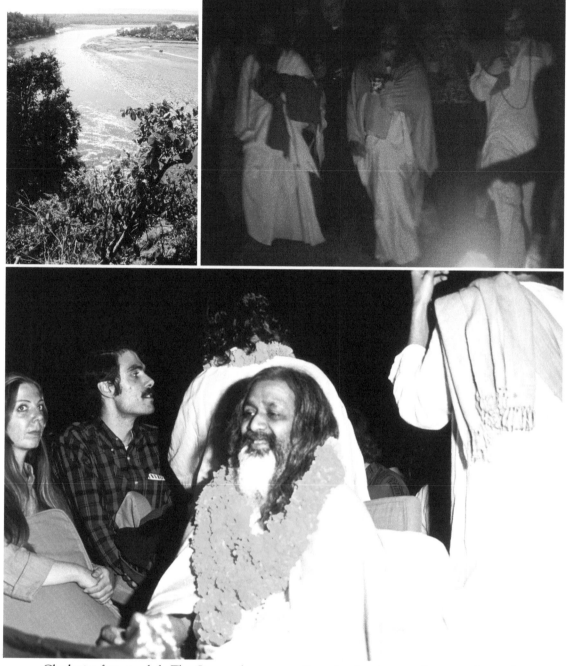

Clockwise from top left: The Ganges downstream from the Academy, walking to a boat ride during the full moon, Maharishi with Mary Gerity, Bill Brunelle, Sattyanand, and Devendra

Maharishi did not prescribe diet or belief. Beliefs could interfere with perception. When asked what to eat, he said, "Eat what your mother cooks you." Maharishi scrupulously honored all religions and religious people, and seekers of truth, but refused to ask for belief. He appeared to share his understanding that belief was

30

useful but knowledge better. There was a joke that belief was good, but could be stupid when based on not knowing. For me, science embraces ignorance, recognizing what is not known, seeking to discover answers through hypothesis, observation, repeatability and publication. Great discoveries can come from ignorance—from the process of not knowing to knowing. Thus the ancient practice of meditation was transformed from a practice based on a belief system to a practice explained by science, as is appropriate for a given time. Both are good. Either way, the meditation practice works.

Tibetan
prayer flags

Toward Nepal
through prayer flags

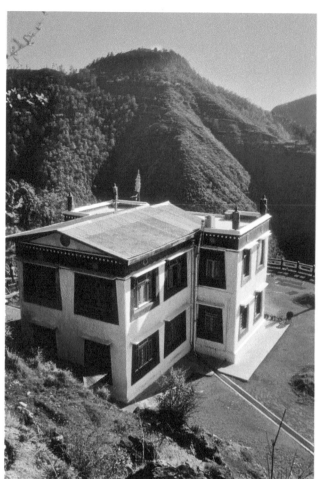

Left: Tibetan temple
Below: Tibetan monastery
with author and friend

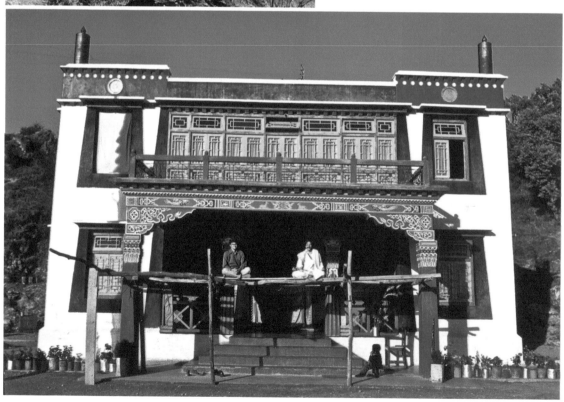

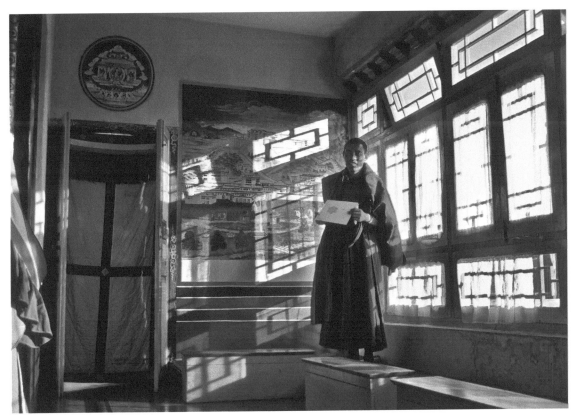

Monk in Tibetan temple

The food at the Academy was healthy, safe, mild and tasty. My first day in the dining hall, I noticed what I thought was a swarm of huge jungle insects; it was a charm of hummingbirds.

If you imagine the dining facilities to be an asymmetric 3-spoke wheel, then the kitchen was at the hub and three narrow spokes emanated from the hub, each perhaps 45 degrees apart. Thus each dining hall had windows on both sides and at the end. There was fresh air all the time, the sights and sounds of the jungle intruding.

The food was always good and nutritious, although not particularly Indian, "to protect delicate Western stomachs," except for the Indian desserts which were traditional and delicious. One dining spoke was vegetarian, one non-vegetarian, and one for eating in silence.

The Academy maintained a small store which sold necessities and sundries such as soap, flashlights and batteries. The ever-capable Bevan Morris was gently in charge.

Before, during, and after the course at the academy, we took occasional ex-

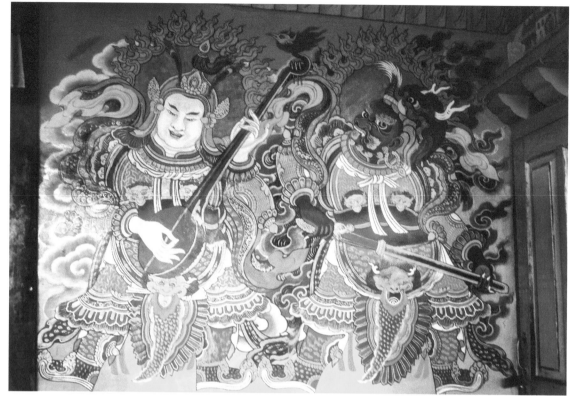

Wall painting in Tibetan temple

cursions to neighboring towns and cities. Pictures depict some of the local people—a Tibetan Monastery in Dehradun, views of the high Himalayas in the distance from Mussoorie, temples.

Inside the academy, Maharishi directed building and landscaping. He took pleasure in providing comfortable quarters for guests and residents. The workers

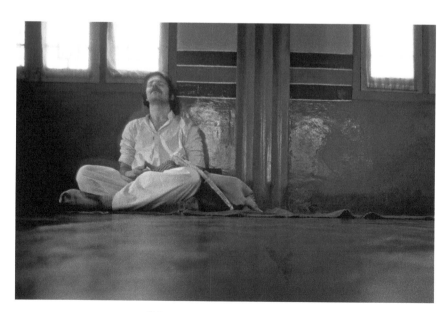

Meditating at the Tibetan temple

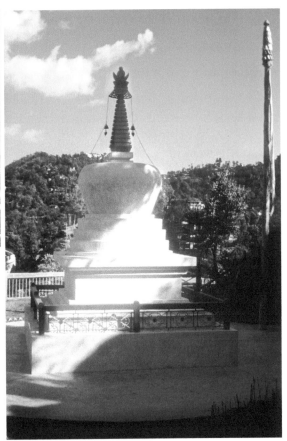

Clockwise from top left:
A view of the high Himalayas
Stupa at the temple
Tibetan with rug
Tibetan children

could be noisy. If you were touchy, that is overly sensitive, that could be a bit of a distraction. We all knew that we could meditate whatever the external circumstances were, but a loud noise could, at an inopportune moment, startle a deep feeling of quiet bliss. Maharishi said throw some stones (pronounced like sitoons) at them if they are too noisy. We laughed. There are pictures depicting brahmacharis directing workers, and workers laboring in the academy.

Maharishi liked to have pools of water and fountains in the academy—for the aesthetics and the cooling. There were lovely reflecting pools. Maharishi's cottage sat on a bluff near a garden overlooking the Ganges. In the basement was a simple meditation cave. There was a living room for meeting with people, a small bedroom and a small personal kitchen. There was a story that a stray dog came by and Maharishi adopted the dog for a while. We were told by the brahmacharis, constant sources of information, that Maharishi slept only about two or three hours a night. We heard that one night the dog, considered a reincarnated sadhu, sleeping under his bed, howled in the middle of the night, and was banished from the bedroom. No essential credence was given to these stories.

Left: The Choti Wala, mascot at the local restaurant.
Right: Family shrine

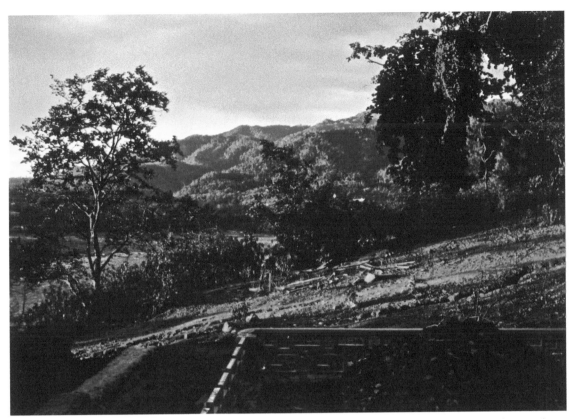

Construction at the Academy

On rare occasions, friends and I would walk down the path into Rishikesh to get ice cream. Once at a tiny shop, a young man adorned as a choti wala provided me with homemade pistachio ice cream. It was delicious, but it had rather explosive digestive consequences for at least a few days. Wala (or walla) is anybody who does anything. It's a very useful word. Chai wala gets the tea. Choti wala has a unique hairstyle and looks like a friendly, helpful demi-god or demi-demon.

More often, as the days grew warmer and longer, and when there was time, we would traverse a short jungle path to go swimming in the Ganges. I found that if I swam as fast as I could, with more enthusiasm than technique, I could slowly swim upstream. The water was flowing quite fast, and we usually swam along the shore. We had heard that here in the foothills of the Himalayas, the Ganges water was pure and antiseptic, essentially antibiotic. That you wouldn't get sick bathing in the water even if you inadvertently drank some. I never felt ill after swimming in the river. This halcyon theory was given pause, however, when, one time, sitting high above the river, we saw a dead cow floating down the river, feet up in the air, with several people sitting on its carcass, paddling.

Maharishi loved boat rides, particularly during full moons. One evening, later on during the course, small motor boats were chartered, and we walked down to the Ganges in the dark, and entered open boats. It was lovely to walk down to the Ganges under the full moon.

Once, the motor on our boat did stall as we were returning to shore. I was sitting near Maharishi. Maharishi closed eyes for a moment, and then a moment later, the motor restarted. I do not offer any proof that he did effect that result. It simply happened that way. However, several years later, when he revealed the TM-Sidhis® procedures, a possible explanation became apparent.

Once crossing the Ganges river, I cheerfully asked Brahmachari Sattyanand what would happen if the boat sank? He equally cheerfully replied, "Moksha!" (the Sanskrit word for liberation).

In Chapters 4 and 5, I will describe the most notable and distinct day trips and sojourns—to the cave of Sri Tat Wale Baba in the jungle near Rishikesh, and to the ashrams of Sri Anandamayi Ma in Dehradun and Mussoorie.

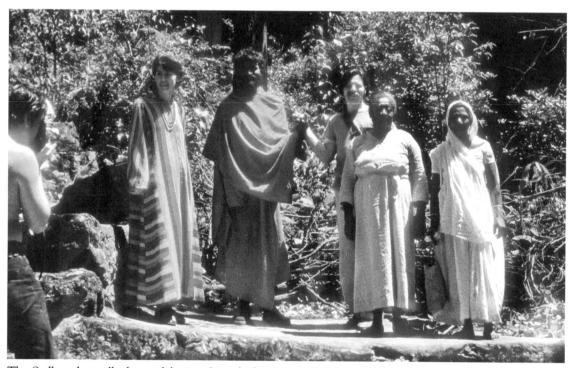

The Sadhu who walked out of the jungle with the denizens of the Academy, author included.

AT THE ACADEMY DURING THE COURSE

"Enjoy the wisdom of life and radiate it for all to enjoy."
- *Maharishi Mahesh Yogi*

Just after the course began, it was Maharishi's birthday. We gathered in the lecture hall, some sitting in chairs, others sitting cross-legged on mats on the floor, and we sang a version of Happy Birthday to Maharishi. The brahmacharis (I never heard who in particular) had procured hundreds of flowers and leis and we

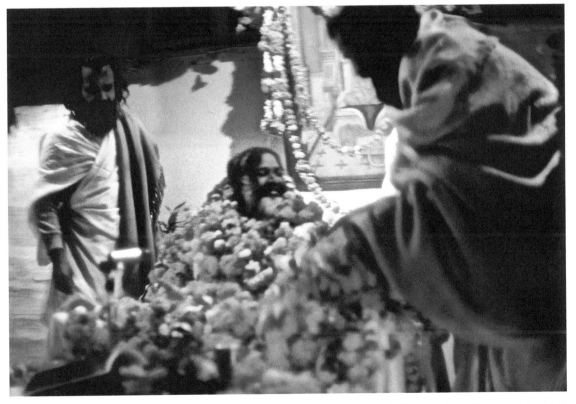

Maharishi, January 12, 1970 with Brahmachari Sattyanand on left
and Brahmachari Devendra on right— a Birthday Celebration

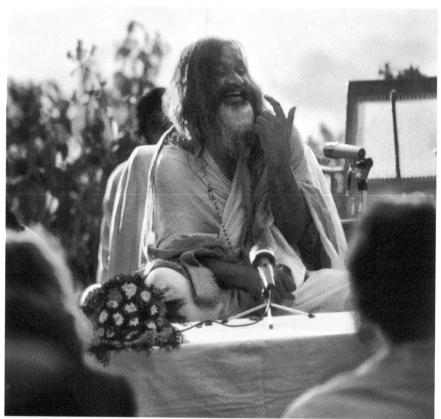

Top: Lecturing behind the lecture hall, above the Ganges
Bottom: Maharishi in the lecture hall

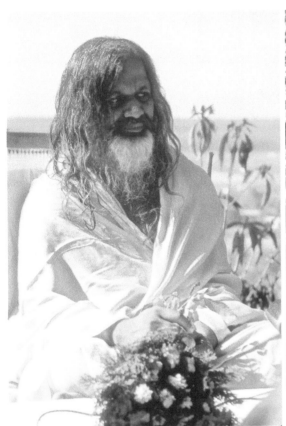
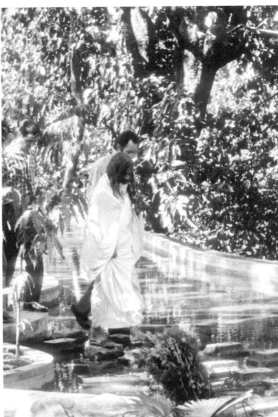

Left: Maharishi outdoors above the Ganges
Right: Maharishi crossing reflecting pool

each were able to walk up and either hand Maharishi a flower or place a garland around his neck. Soon he became covered in flowers. He was very good natured and thought that this was hilarious.

Maharishi began his talk that evening by saying that the birth of the individual is rooted in the birth of creation. In his discourse, he identified each wave on the ocean of life with the entire ocean so that the individual recognizes his identity with the cosmos.

The first part of the course could be called the wisdom part of the course. Maharishi wanted everyone to understand higher states of consciousness from an intellectual point of view, not just theoretical, but rather explained systematically and practically. This was one of Maharishi's greatest contributions—the systematizing of traditional, perhaps secret or hidden knowledge of enlightenment, the things spoken of by seers, mystics, poets, spiritual leaders. Although known to Yogis, Buddhists, Mystics, Saints, and others, it was passed from teacher to student and not

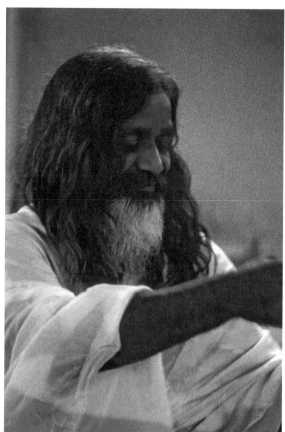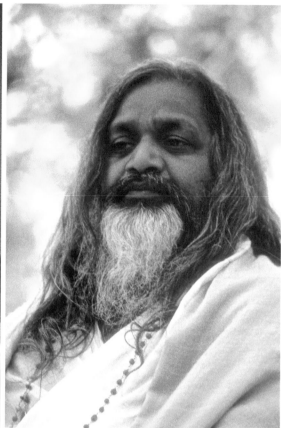

Left: Maharishi performing puja
Right: Maharishi in thought

well known in academic or scientific circles.

Additionally, Maharishi was the first to explain publicly the progression of higher states of consciousness in systematic, even scientific terms. Later in the course, more time under Maharishi's supervision would be devoted to meditation to have deeper experiences of the matters of the discussions. Finally, the course would progress to a phase where the students would learn how to lecture about, check, and teach the TM technique.

One does not climb the ladder of consciousness in an orderly and systematic manner. States can come hodgepodge. By having an orderly structure of understanding, one can place one's own or another's reported experiences at various hypothetical points along a continuum. Understanding the structure is best evident with hindsight. Maharishi's explanation of a continuum of the growth of consciousness is a tremendous contribution to the field of the development of human potential. Those who have achieved higher states may not wish to examine their own

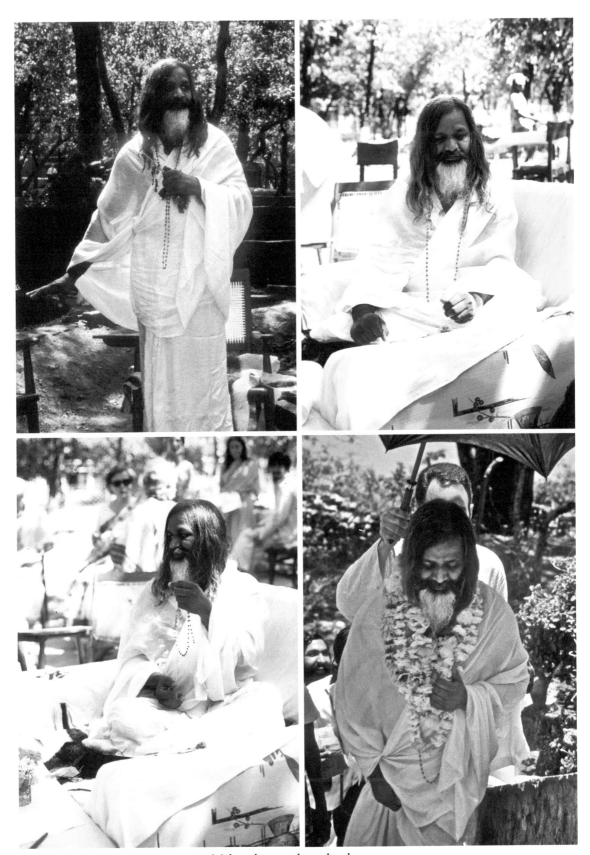

Maharishi outside under the trees

43

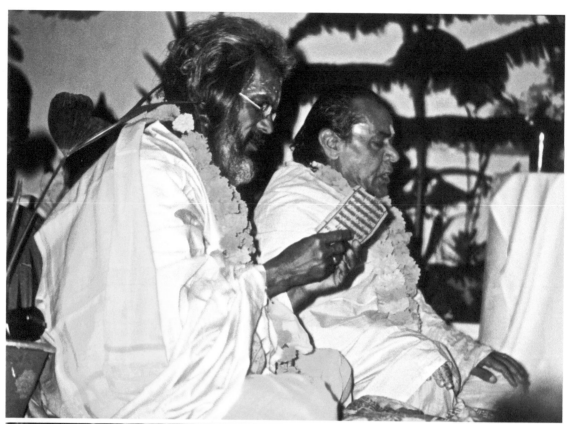

Top: Visiting pandits
Bottom: Maharishi, Devendra and Sattyanand

44

Sattyanand observing pandits performing a Vedic ceremony

lesser states of awareness to restructure understanding. Lesser states would be less enjoyable.

How do you explain a state of awareness, or anything else for that matter, to another who has not had your experience? You find common ground and then use metaphor. Describe the taste of an avocado or an ice cream to one who has not had that pleasure? Or describe a color?

Unity. Imagine that a plant is made of sap, nothing other than sap. Although the sap is expressed in leaves, thorns, stalk, petals, those being made of sap, the sap is unseen. What if there is a universal property to life? What if consciousness is the ultimate nature of life?

Ancient Sanskrit scholars spoke of Sat Chit Ananda—unchanging, eternal consciousness that is ananda, bliss. Bliss is not giggly blissful. It is all encompassing. Pure Consciousness is self-sufficient. Maharishi had said that honey can be so strong as to not even taste sweet. Bliss. The first goal of meditation: Experience Pure Consciousness that is the essence of life. One surprise of the technique of Transcendental Meditation is that it is easy to do this effortlessly.

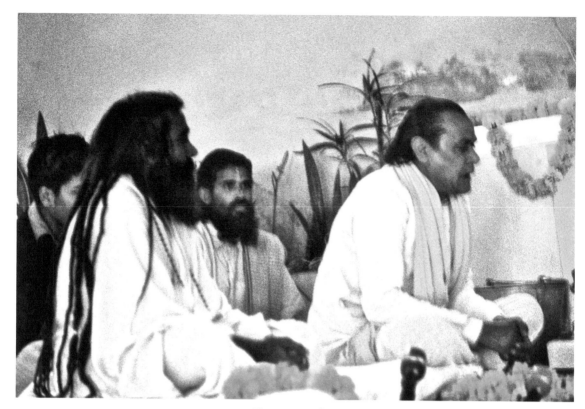

Visiting pandits

Another precept is that as one grows in consciousness, one has the freedom to develop abilities, "powers", as it were, which are considered a great distraction to spiritual growth. This is discouraged. If some ability comes naturally, so be it. But don't go looking for extraordinary abilities. The message: First capture the Fort. That is, first gain enlightenment, then let other abilities develop naturally. In later years Maharishi would put this under his rubric of the principle of the highest first. (However, Maharishi later developed the TM-Sidhis® program to enhance and accelerate the development of consciousness. This would not be announced for several more years.)

As you practiced meditation regularly, you would find the values of Pure Consciousness becoming part of your waking, dreaming and sleeping states of consciousness. This inner awareness whether small but present, or huge like the cosmos, would provide comfort and stability to your life. When the inner consciousness was 100% full, as large and as unbounded as the universe, while awake, dreaming and sleeping, you might be in Cosmic Consciousness. This is "The Fort."

One consequence of the growth of consciousness is the ability to perceive

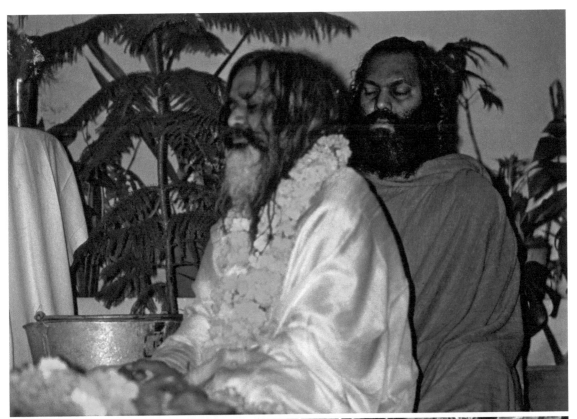

Top: Maharishi and Devendra
Bottom: Maharishi in the garden with teaching tables

47

Maharishi conferring with Jerry Jarvis

life in a more refined and subtle manner. Each of the senses—touch, taste, smell, sight, hearing—has subtler realms. Maharishi explained that as you gain the ability to experience the subtle realms of the senses while established in Cosmic Consciousness you could eventually be able to perceive the finest impulses of creation emerging from the absolute. Physicists talk of an uncanny parallel to the quantum mechanical theory of the ground state which is a state of potential energy. But rather than attributing this to random uncertainty this direct perception of the impulses of creation is called God Consciousness. What makes this different from religion is that it is considered a direct perception rather than a belief system: it is only a hypothesis unless or until it is your experience (or you have experiences conducive to this understanding).

The experience of God Consciousness ("GC") is considered to be so strong, so overwhelming, as to threaten the stability of Cosmic Consciousness. One is to live in that state, GC, for some time until the Unity of Consciousness arises. Each wave of the ocean is an individual aspect of the whole ocean; the individual can recognize her identity with the wholeness of the ocean.

Another consequence of the growth of consciousness is the ability to act in accordance with the Laws of Nature. This means that your actions automatically support universal principles and are supported by them. The Laws of Nature reside in the Pure Consciousness that is inside of you.

A different aspect of this is: "As you sow, so shall you reap." Maharishi would say this slowly and with great emphasis. A Vedic saying, "hayam dukham anagatam" from Patanjali—was one of the few things he would often quote in Sanskrit. It means: Avoid the suffering or danger that has yet to come. By aligning yourself with Pure Consciousness and the Laws of Nature, either you avoid things that are coming at you or at least their effect is mitigated.

So the path is to capture the fort first. That is, gain Cosmic Awareness. Then explore all of the finer levels of creation until you experience the finest impulse of the unmanifest manifesting, God Consciousness, the sixth state of consciousness, as it was affectionately called. Maharishi saw that the seventh state isn't a state at all—it is the unity of all consciousness. You need to be living in the sixth state and then over time the seventh state dawns either due to self-realization or due to

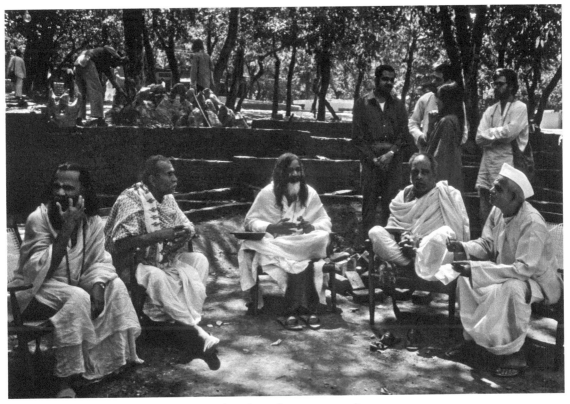

Maharishi with visiting pandits

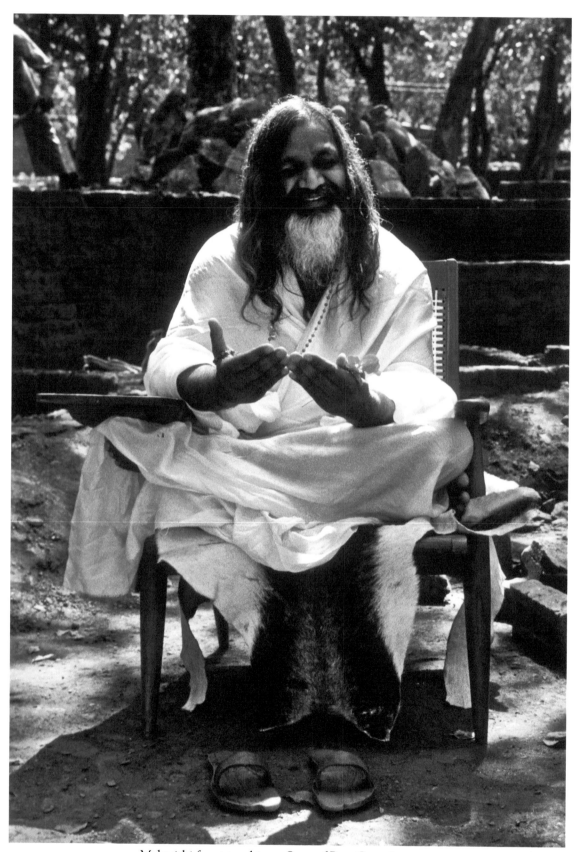

Maharishi forest teaching—State of Pure Consciousness

Mahavakyas—the great words spoken to you at the right time by an enlightened master. Incidentally, Maharishi explained that it can be difficult to distinguish between Cosmic Consciousness and Unity Consciousness since both are dominated by the experience of the Infinite.

Maharishi characterized himself as a humble, but thoroughly devoted student of a great teacher, but that student had achieved a state of authority. A couple of years later, while studying sociology, my friend Daniel Jackson and I picked sociological topics to study. I started out thinking of Transcendental Meditation as a sociologically coherent teaching. Daniel was evaluating the TM group as a social movement. Before we had gotten any further in our research than a few cups of coffee each, we became enthralled with the topic. My thesis turned out to be an examination of the growth of social movements and Maharishi's authority was that of a "charismatic leader" as defined by social theorist Max Weber—one whose power comes from force of personality rather than delegated to him by various channels of social authority such as family, tribe or government. I spent a year and a half writing my honor's thesis in the Sociology of the TM movement and was awarded an honors degree as a Senior Scholar. My advisor Kingsley Birge was a gentleman, saint (to ease me through my study blocks), and a true scholar. I wish my thesis had been more greatly shared and distributed. I held on too tight. It is now on-line at the Colby College website.* Another relevant construct I used was to consider Guru Dev, Maharishi's teacher, a man of ideas, the man of words and concepts as defined by Eric Hoffer, and Maharishi as the practical man of action.† I did not read Daniel's thesis until I had moved to Seattle in 1977 to study physics where he and his wife Sally graciously took care of me.

Often the lectures at the beginning of the course were held outdoors. There was a bluff above the Ganges behind the lecture hall where we would sit. Sometimes the crows would make a racket. Maharishi once said, "Don't they sound like a pack of fools?"

During the course, pandits (now often called 'pundits') would come to visit.

* Miller, Jonathan Lewis, "Growth of transcendental meditation: a sociological study" (1973). Senior Scholar Papers. Paper 181. http://digitalcommons.colby.edu/seniorscholars/181

† Hoffer, Eric. *The True Believer: Thoughts on the Nature of Mass Movements* (Perennial Classics, first 1951).

At that time, the word pundit had not entered the American mainstream. The Hindi word from the Sanskrit "pandita" was "pandit," a learned and scholarly person. Pandits could memorize texts, perform ceremonies, and render teachings and opinions, a status here something akin to a professor. These individuals were men, dressed in traditional garb, unshaven, serious. Maharishi treated them all with warmth, graciousness and great respect. They responded in kind, to the perhaps unanticipated warmth and hospitality.

This was always my experience of Maharishi throughout the times I saw him personally from 1968 on: he always treated people with great warmth and respect. He stated he had a special place in his heart for the religious people of all religions. He was also particularly fond of scholars. Doctors, lawyers, government officials, military—all were treated with warmth and respect. I am not sure how he felt about reporters, who might embellish their reporting.

In 1971, in a TM conference in Amherst, Massachusetts, Maharishi shared the stage with Buckminster Fuller. Buckminster Fuller was so taken with Maharishi that he at times turned his back on the audience and said that his entire discourse and dialog over three days was directed at Maharishi, since Maharishi was the only one who could comprehend the entirety of what he was saying. I was fortunate in that my father was on the stage part of that time representing medical scholarship. One time, while leaving the conference hall, Maharishi said to the group of us nearby that Buckminster Fuller seemed to represent enlightenment, but it was hard to tell whether it was Cosmic Consciousness or Unity since the two appeared so similar. It was one of the very few times I ever heard Maharishi comment on someone's consciousness.

Pandits visiting the Academy in Rishikesh would receive Maharishi's hospitality, visit him in his garden or in the lecture hall. They would converse about finer points of the Vedas and the Upanishads, ancient works by rishis (seers), illuminating the understanding of and path to enlightenment.

Maharishi explained that knowledge came to seekers in different forms. Enlightened sages, rishis, seers, would cognize in their own consciousness the elements of knowledge and wisdom. This is essentially self-cognition, the Self becoming aware of its Self within itself in Pure Consciousness. The literate body of this

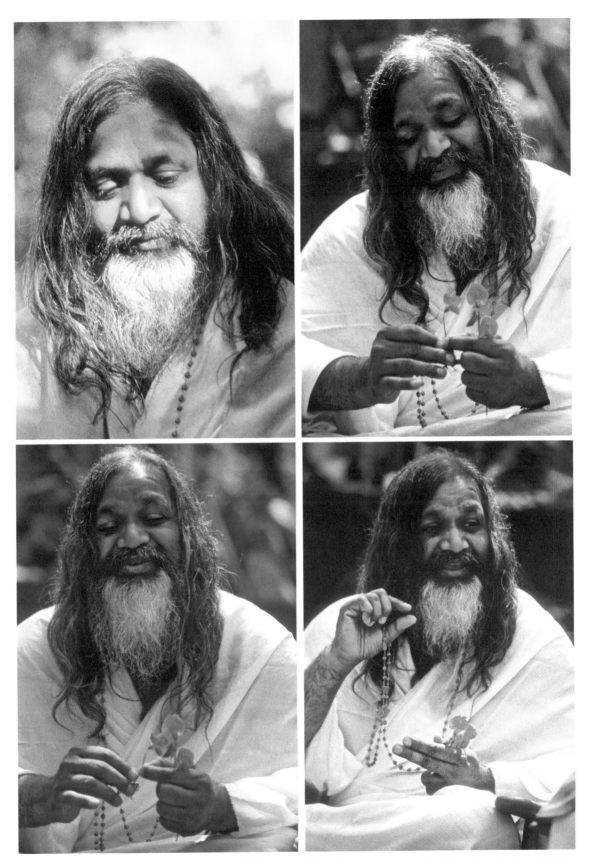

"The flower is nothing other than sap, and the sap is Pure Consciousness at the finest level of creation"

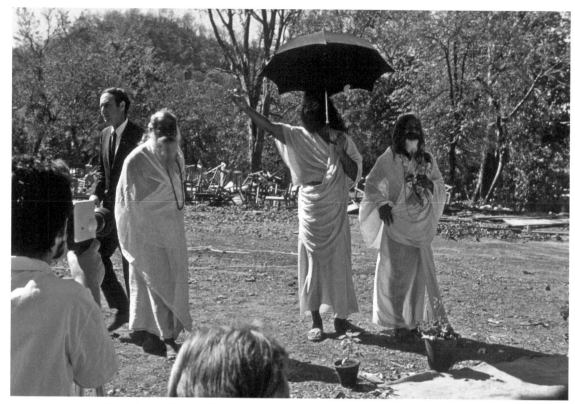

Jerry Jarvis, Swami Shankerlal, Brahmachari Devendra, and Maharishi

self recognition or cognition is called the Shrutis. Other knowledge is knowledge that is passed from teacher to student. This intellectual transmission of knowledge is described in the Smirtis. This is traditional knowledge and other forms of study. Then there are the Puranas—the stories that illustrate the knowledge. You can research these terms. Maharishi's explanation cuts to the heart of the meanings.

These are not foreign concepts. In science, the revelations, the moments of "Eureka" by the great scientific seers are recorded in their remembrances in publication and discussed by their peers and others. In religion, in Judaism, for example, we have revelations, traditional knowledge, and stories. The four questions of the children at Passover teach by story and example. In Christianity, the stories are called parables. In the body of law of the U.S. government, we have direct pronouncements of the executive and legislative branches, and then there are learned discourses and commentaries from the published masters (pandits) such as Lawrence Treib, Learned Hand and many others. The stories found in the appellate and case law illustrate the meanings of the law. There are archetypical forms for the passing of knowledge.

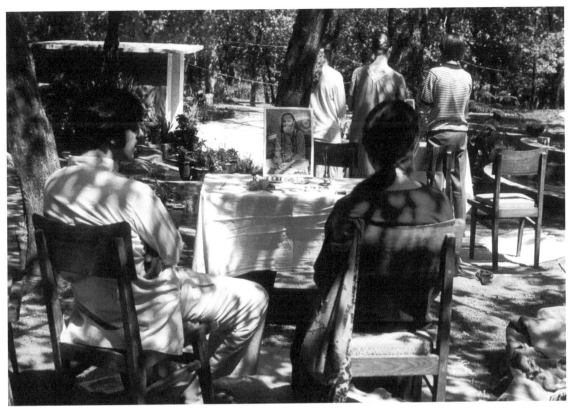
Phil Bombace and Jacqui Bombace Davis

The discourses between Maharishi and the visiting pandits in Rishikesh were mostly in Hindi, and we would get glimmers of the discussions. Sometimes Maharishi would comment on a particularly insightful statement by a pandit. This was essentially a multicultural experience and one for enjoyment more than edification. At times we witnessed traditional pujas (ceremonies), but we were not taught, nor asked to participate, nor could we understand the words. We were not taught Hinduism, and anything learned was incidental. This was not the purpose of our being there.

As the course progressed, lectures were cut to twice a day and then once a day, evenings only. We increased meditation time and added doing yoga asanas many times a day to keep our physical health. We could take walks at will with our friends around the Academy or down to the Ganges. This was a time for deep rest and deep silence under close supervision. Eventually, and for three weeks, we were given leave to meditate quite a bit each day. We would break for yoga asanas, walks, and take meals regularly throughout the day. Many of us had exquisite experiences of bright lights and hot fluid rushing up the spine. Maharishi supervised closely. It

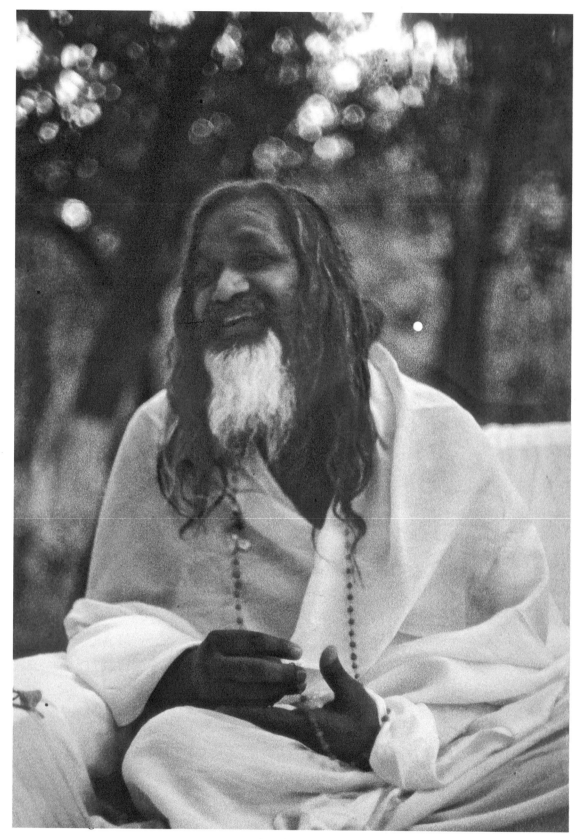

Maharishi smiling

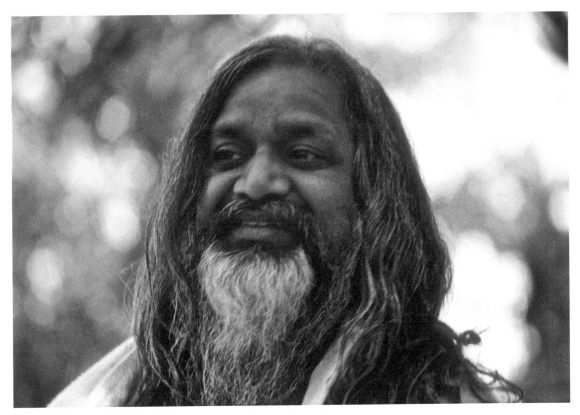

Maharishi smiling

began warming in March.

Maharishi had said that when he was young, he was in the habit of visiting saints, and we were welcome to do so as well. Enjoy their company but do not do their techniques, because it is ineffective and, "unsafe to go down a river in two boats at once."

There was some available time for excursions and visits. Tat Wale Baba, a famous saint who wore a loin cloth and lived in a cave in the hills near Rishikesh, visited the course. Maharishi greeted him with extraordinary warmth and appreciation. I was standing nearby as Tat Wale Baba approached down a mountain path and I saw the love in Maharishi's eyes for him. Maharishi took his hand and led him indoors.

I later heard that Tat Wale Baba was blind. When he was asked if he was blind, he said, "These eyes do not see." He navigated through the steep jungle trails from where he lived near the Academy. He came into the lecture hall and sat cross-legged on a dais near Maharishi. Maharishi translated for him. I do not recall Maharishi translating directly for anyone else. I asked, "What is the relationship

between Man and God?" Tat Wale Baba answered, "Fullness on both sides."

Maharishi had said that Tat Wale Baba was a simple saint, one who saw everything in terms of Unity of Consciousness and answered accordingly. There was the story that an English lady had asked him if he had been to London. He was reputed to have answered, "I am London."

Maharishi defined the term "saint" as one who does no harm. This is a remarkably precise yet folksy explanation in the sense that one's actions ramify throughout and eventually come back to us. In order to do no harm, one's actions must be dharmic, that is, support all of life, be in accordance with all of the Laws of Nature. That was how we spoke back then. Since that time the most esoteric laws of physics and science in general have become more well-known, and concepts of the wave-particle duality, the uncertainty principle, the quantum ground state, the big bang theory, the God particle, the theory of quantum gravity, the unification of all laws of physics (GUT), string theory, special and general relativity and so forth are bandied about whether understood or not. The fact that these theories may apply to spiritual and mystical experiences (or not!) have been embraced in countless highly readable tomes. In this case, a saint is one who does no harm through personal attunement to Pure Consciousness and all the Laws of Nature.

At later times, I walked through the jungle to visit Tat Wale Baba's cave to listen to his discourse. I will recount what I can of that in a chapter to come. Toward the end of the course a group of us took taxis to Dehradun and Mussoorie to visit the ashrams of Anandamoyi Ma, another great saint. That too is recounted in a brief chapter and with photos.

The weather was getting quite warm as the seasons churned towards an Indian summer. We would go down to the Ganges and swim.

Then it was time to get ready to go. As I recall Maharishi was making teachers one by one, that is, providing final authority for each to teach. I was in the cafeteria on a particularly balmy afternoon. The cooks had made some home-made ice cream that was chilly and creamy.

I got a tiny scoop of vanilla ice cream and politely asked for more, while my friends were wolfing down huge globs of seconds and thirds in the hot Indian springtime. The wale (worker fellow) refused me defiantly for no obvious reason.

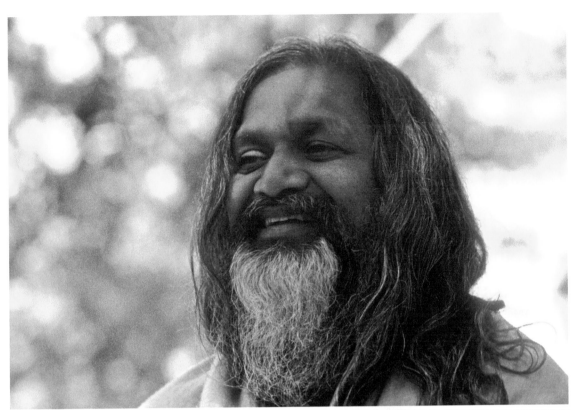

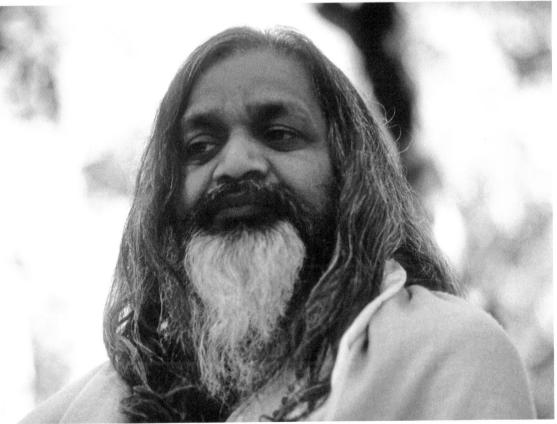

Maharishi teaching outdoors

I said, "Why not me?" Without thinking, in a flash, I reached out and lifted him up off the ground with my right hand holding his shirt. I saw him a foot or two in the air and thought, "What in the world am I doing?" I gently put him down and apologized. I thought, this isn't my nature. I am bothered not by the ice cream, but by the thought of leaving.

I hastened out of the cafeteria and took the wooded path to Maharishi's house. As I approached, I saw Maharishi who was sitting cross-legged in a chair in his garden interviewing people one by one. As I approached, my energy like a tsunami, everyone who was there, seemingly without volition, got out my way, parting like the Red Sea, to create a path for me. Maharishi and I were then alone. I knelt down so that he could hear me speak. I said, "I realize that I don't want to leave." He said, "Then stay."

Then without a pause, he said, we will stay here for a while, then you will go to Bangalore with me, and then later to Europe and to the USA. This was all news to me, but it seemed as if he had thought the whole thing through. I felt a great weight lift.

The time flowed with placid bliss, the blessing of Maharishi's presence. There were only a few dozen of us or less, along with the brahmacharis and Bevan Morris who lived there and managed many things. In the warm evenings, we would sit on Maharishi's roof under the moon and starlight and he would converse about diverse topics.

It was all entertaining, warm, intimate, and joyful. Susan Shumsky, a course participant and friend, painted a lovely portrait of us sitting on the roof. In the portrait I see Bevan sitting in the back, Sattyanand to the side, Susan Seifert and Jerry Jarvis are there too and many dear friends including Fred den Ouden and Geoffrey Baker of whom I will have more to say later.

One afternoon, I was invited into the meditation cave underneath Maharishi's living room. He was resting, and someone was massaging one of his calves. I was invited to massage the other one. I barely did so due to incredible shyness and tentativeness. I had too many barriers. I recall my friend Elliot Abravanel, a doctor, telling me once that he was holding Maharishi's wrist, taking his pulse, and the pulse was silky smooth. I recall my father, a practicing surgeon, that summer in Poland Spring, Maine, examining a small, harmless growth on the back of Mahari-

shi's hand that my mother had noticed while we were sitting in Maharishi's private meeting room. It is hard to grasp that a human in a human body with a human nervous system can achieve such great states of consciousness. But that is the whole point, isn't it?

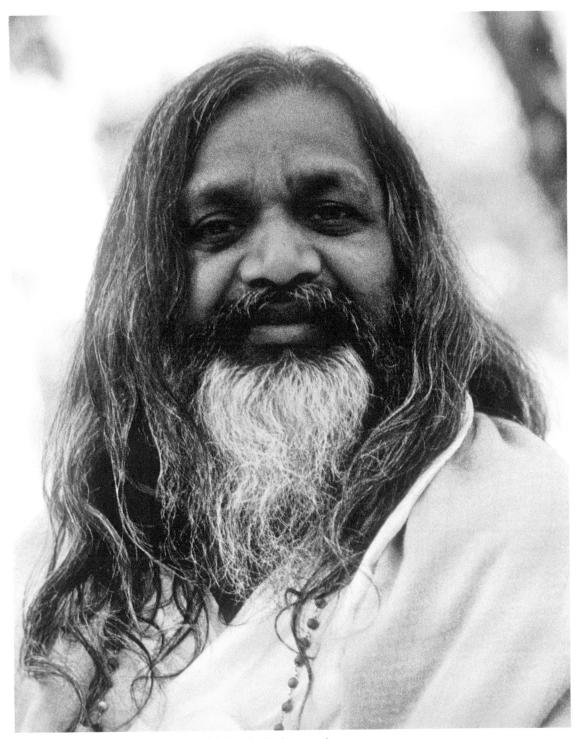

Maharishi looking at the camera

CHAPTER 4

SRI TAT WALE BABA

"Fullness on both sides."

- Tat Wale Baba

*I*n the middle of our Teacher Training course, under close supervision, and with certain schedules and requirements, Maharishi increased our meditation time. It's not that we practiced the TM technique hour after hour, it's just that we would

meditate for a specified time, rest, practice yoga asanas and begin again. It was all supervised with reports to Maharishi, and each of us kept a weather eye on our buddies. Meals were offered three times a day, but sometimes one was less hungry and ate less. We would take daily walks through the Academy or down the jungle paths to River Ganges. The scenery was benign and gentle. The program unforced and easy.

Occasionally a sadhu, that is either a white-clad or orange-clad renunciant would emerge

Sri Tat Wale Baba in his cave
in the jungle near Rishikesh

Sri Tat Wale Baba in his cave

from the jungle. These mendicants were greeted warmly and treated with great respect. They would be offered food and water. Sometimes they would stay, even visit. Others would simply disappear into the jungle, melting into invisibility.

I remember several of these sadhus. Some were fairly young, others more elderly. One middle-aged fellow (I am not sure what middle-age means—after all, as my son explained when he was about 5—almost everyone is either younger or older than you) was named Ananda. Ananda is the Sanskrit word for 'bliss'; it has various connotations from contentedness to self-sufficiency to supreme joy.

I particularly liked this man because he seemed to embody carefreeness. What does it mean to be carefree? He did not seem to have a care in the world. I have never seen such unfettered joy and ease of the soul. How is it that a simple life of renunciation can provide supreme joy?

Maharishi certainly appeared extraordinarily calm, peaceful, reactive only by choice. But no one in the Academy was carefree. Everyone had responsibilities and concerns, whether it was fulfilling their appointed task or perhaps saving the world. Maharishi had set a personal goal of bringing peace and prosperity to the world: 200% of life; 100% inner joy and 100% outer success. Swami Ananda-ji was carefree.

The sociology of Indian culture involves degrees of renunciation—that is, the inverse of involvement in the world. A 'brahmachari' is a student. Under the ancient Hindu ideal, a person is first a student, then a married householder, then an elder, and finally a renunciate. As a student you live a life of celibacy, and study of scripture, meditation, and perhaps other worldly fields of knowledge and training, from fighting to debating. As a householder, you earn a living and care for your family. Later, perhaps around 50, if you follow the quartiles of aging (25-50-75), you become an elder of your community and assume responsibility for helping govern and lead your village. In that sense you are a governor amongst governors. Then, when your youngest child is married (I think it is fair to assume that then children married in order of aging), you are free. Then the time has come to renounce your worldly responsibilities and your wealth and your concerns. You may want to live in a forest or a cave, do calligraphy, write poetry like Miyamoto Musashi or meditate like the rishis and the seers of old to attain the deepest understanding of life. Ma-

harishi taught, however, that you need to attain enlightenment now, here, as soon as possible, and not wait.

Some people for various reasons known only to themselves choose to renounce the world earlier. Brahmachari Sattyanand told me that when his wife died he decided that nothing in the world held him and it was time to live with Guru Dev. Maharishi explained that his teacher, Swami Brahmananda Saraswati Maharaj (Guru Dev) at a very early age decided that nothing was worth living for but the Supreme Absolute, the ultimate, God, and chose a path of renunciation to expedite the process of attaining that, through one-pointed devotion to the highest ideals of life. There is a story that he questioned meditation teachers while he was eight to ten years old, prevailed in debates with his elders, until he found a teacher, kind, compassionate, enlightened and wise—Swami Krishnananda Saraswati in Uttarkashi, Himalayas. Maharishi retells this story in his Introduction to his short book, *Love and God* (Maharishi International University, 1973).

When Guru Dev was 27, with his master's direction and permission, he entered a cave determined to not emerge until he had achieved Supreme Realization. At the age of 34, Guru De chose to be iniated into the order of "Sanyas"—renunciates—by his Master at the Kumbha Mela.* Maharishi explained that after that, he lived alone in the forests and jungles for nearly 40 years. When he practiced whatever he did, no animals would fight for a mile around him.

When Maharishi was a student, he related that he was in the habit of visiting saints, and he saw Guru Dev in some car headlights. Maharishi immediately felt his divinity and his grace. Maharishi has said that at that moment, he instantly knew that, "He was It." But Guru Dev (traditionally, 'guru' is one who removes obstacles and brings light, and 'dev' indicates divine, heavenly, full of light), sent Maharishi back to school to finish his degree (the equivalent of a master's degree in physics).

There are some sadhus who come from certain backgrounds and castes, and take certain vows: They are entitled to wear orange as a sadhu or swami while others such as yogis and brahmacharis wear white.

There is one story that illuminates the significance of orange or ochre color. Maharishi taught that when you meditate you dip into Pure Consciousness—that

*Love and God, p. 8

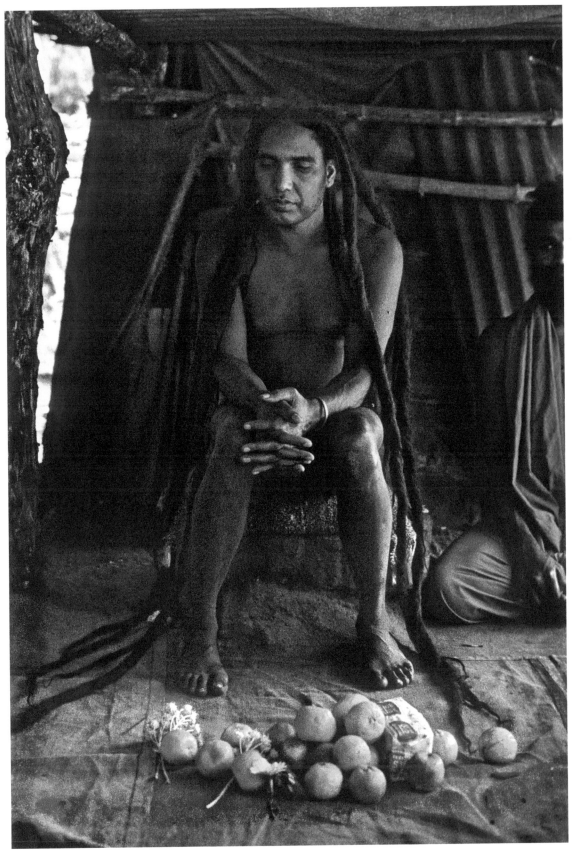

Sri Tat Wale Baba with offerings from devotees

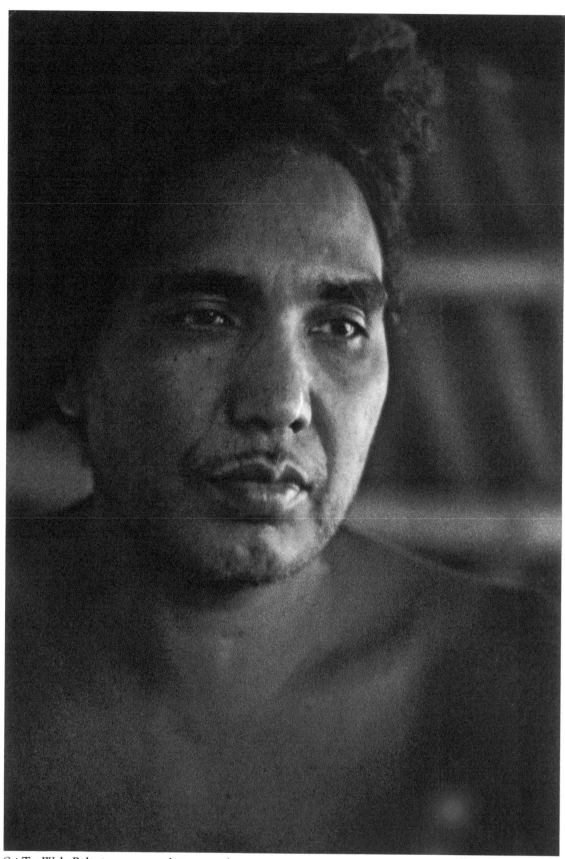

Sri Tat Wale Baba in a contemplative mood

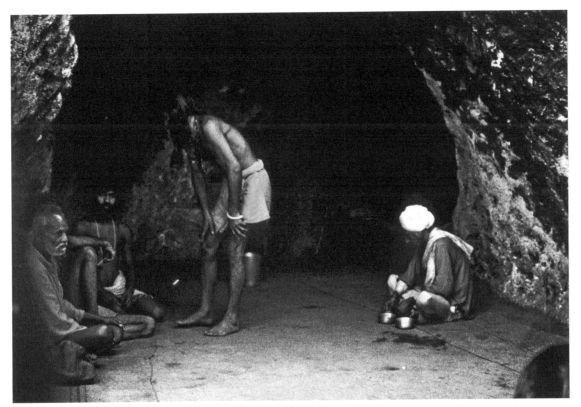

is analogous to dipping a white cloth into yellow dye. Then you dry the once white, now yellow cloth in the sun. That is a metaphor for first meditating, and then diving into action. By repeatedly dipping and drying the color becomes fast. Eventually, the color is the same dipped or dry. The mind is drenched in Pure Consciousness, and by alternating action and meditation, the qualities of Pure Consciousness become permanent. Having dipped the cloth only one time, the cloth is never the same—it has had a taste of the absolute—sat chit ananda—the pure awareness that is unending self-sufficient bliss.

Living in the Academy, on a permanent basis, were a series of younger and older men who were considered brahmacharis—seekers of enlightenment and students of Maharishi. These were all delightful folk. Brahmachari Sattyanand was senior—he had been a direct disciple of Guru Dev's and he spoke English well. He confided in me that now the most direct route to Guru Dev was through Maharishi. Sattyanand was always warm, witty, and cheerful. He was a dear friend.

Brahmachari Devendra was a tall and stately man with dark oiled hair, dark skin and a stern demeanor. He had been a royal barrister in the UK. But when you

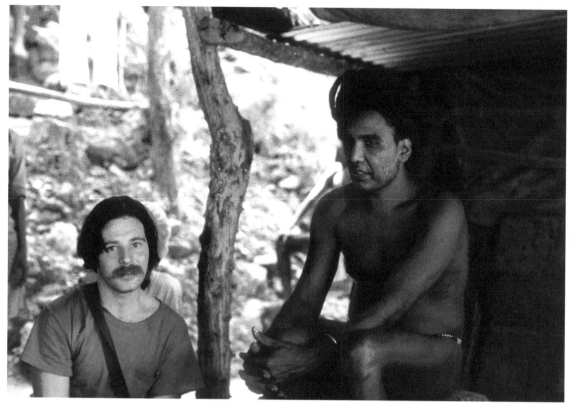

Author visiting the Great Saint

spoke to him, as with everyone, he was warm and charming.

Another of whom I was particularly fond was Brahmachari Nandkishore. Quick-witted and cheerful—I once mentioned to him that even without enlightenment Maharishi was a genius, a brilliant man and a scholar. Nandkishore roared with laughter and corrected me: Maharishi was enlightened because he was a genius.

An older brahmachari living at the Academy was Swami Shankerlal. He seemed roly-poly (perhaps thinner than some of us now) with a luxurious white beard and sparse white hair. He had less to say to us since English did not appear to be a language he spoke; he was always smiling warmly and welcoming.

Rishikesh was known for saints, and a very special saint lived in a cave not far from the Academy. He was called Tat Wale Baba (the saint who wears gunny sack) and in fact he was nearly naked. He was a striking man, very tall, with about six feet of hair curled around his head, wearing only a chain around his waist from which hung a simple loin cloth and a band around a wrist. He was beautiful to behold. From a distance he appeared no older than a perfect teenager. Rumors

abounded that he was 40 or 60 or 80. He lived in two caves side by side in the jungle at a distance one could walk from the Academy. In one cave he meditated and slept (he was rumored to have slept very little), and in the other he accepted and met pilgrims who made modest offerings of food or flowers. He had a few acolytes who looked after him.

Maharishi invited Tat Wale Baba to meet and address us. Maharishi warned us that he was a "very simple saint"—all that he saw was Unity of Consciousness.

As he approached the academy lecture hall, Maharishi was notified and exited the lecture hall to greet him and lead him in, holding his hand. I had never seen that before. The love from Maharishi's eyes for a fellow enlightened soul was palpable.

Tat Wale Baba sat beside Maharishi on a dais. Maharishi translated for him—a solitary honor. Tat Wale Baba gave a very short talk and then entertained questions. I remember asking, "What is the relationship between Man and God." Tat Wale Baba's answered, "Fullness on both sides."

Someone asked that if it were true that he was blind (he was rumored to have cataracts). He replied, "These eyes don't see." We had seen him carefully picking his way barefoot through mountain jungle paths to the Academy with no aid.

Later I was fortunate to walk up to his cave through the jungle and be there when he was holding audience. Then it was a true Indian scene with pilgrims and skeptics who had come from more populated areas to see the great saint.

Someone asked him, "Why is the Ganges holy?" He answered (through his translators there), "Because it is inside of you."

But with a saint like that, the true value was not in what he said but being in his presence. The word darshan means being able to see the saint or guru. But the deeper meaning is that, by being in the presence of the enlightened person, you receive attunement to that higher state of consciousness. Maharishi had said that he had been magnetized by being in the presence of his Guru Dev. It is fortunate to be in the presence of great saints.

CHAPTER 5

SRI ANANDAMAYI MA

"Jay Guru Sharanam" (Glory to guru as refuge.)

- Kirtan (Chanting) to Shri Anandamayi Ma

Toward the end of the course, returning to the United States was in the air. We had been self-sufficient and quite happy, eating simple foods, living well in the foothills of the Himalayas near the river Ganges, and enjoying Maharishi's gracious company. He was amusing, sometimes hilarious, able to work with any question, fun in his interactions, and very wise. The Academy was replete with creative and good-natured souls.

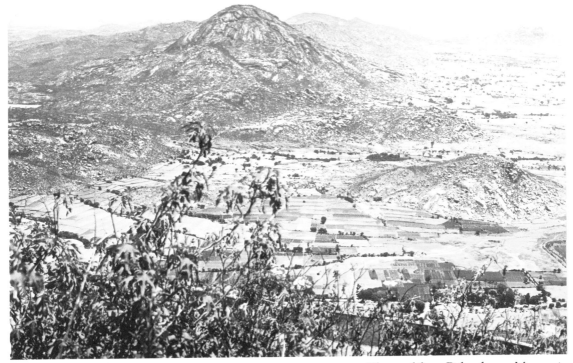

The road from Dehradun to Mussoorie

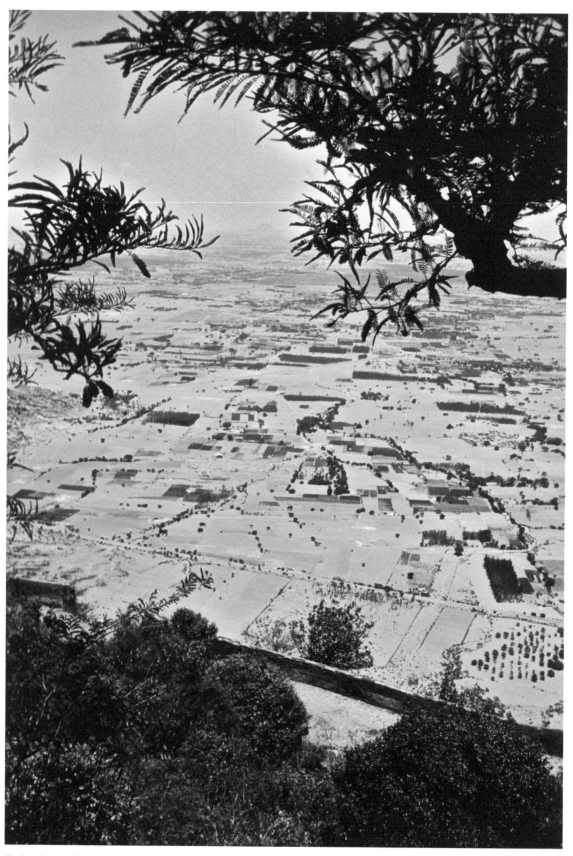

Dehradun to Mussoorie

We had been spending time sitting at tables practicing teaching techniques under the trees and sometimes visiting Maharishi in his garden. At times, I would walk down to the Ganges and go for a swim between the boulders along the shore. I thought of myself as a pretty good swimmer. Although my technique was home-grown, I was enthusiastic and had gusto. I could swim up-river just faster than the river was flowing. Another time or two, friends and I swam across and back ending up much further downriver than where we started.

We had heard that as polluted as the Ganges might be, we were in the foothills of the Himalayas, far from urban civilization where something in the river, whether sulphur or blessedness, kept it pure. I can tell you that I never got sick from the water; but I once saw a dead cow floating down the river, bloated, with several men or perhaps a whole family sitting on it and paddling—with the hapless cow's feet in the air. They may have been vegetarians, but if so, they certainly practiced their vegetarianism in unique ways.

We began to take day trips again to the environs. One time I went into town and as an honored foreigner was offered some green pistachio ice cream by a local restauranteur. I was rewarded with a great case of the flux for a day or two.

One day, I was told that the great saint Sri Anandamayi Ma was visiting two of her ashrams in neighboring villages—one in Dehradun (Dehra Dun) and the other on the road from Dehradun to the hill station of Mussoorie. This was the saint whom Yogananda in his book, *Autobiography of a Yogi*, had made a special point of visiting and to whom he referred as the Bliss-Permeated Mother.

I had heard that Peter Wallace, a young seeker from Los Angeles, had traveled to see the great saint in the 60s seeking enlightenment and that she had sent him to Maharishi. This meeting lead to the birth of the students' TM movement in the United States. Jerry Jarvis recounts that he and Debby Jarvis were living in a one-room stable-cottage in Malibu between 1961 and 1967. Peter Wallace brought his brother Keith to Jerry's house where Jerry gave a talk on Cosmic Consciousness. Jerry Jarvis, Peter and Keith Wallace were the original pillars of the early student TM movement in the USA. The Doors (sans Jim Morrison) began the TM practice and formed their band in Jerry and Debby's cottage.*

* Recollection of Jerry Jarvis.

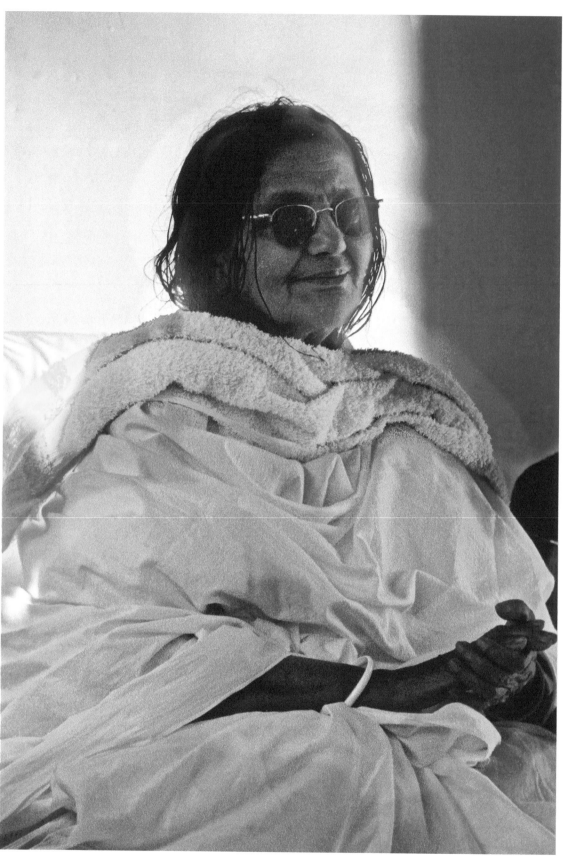

Sri Anandamayi Ma in a Dehradun ashram

Sri Anandamayi Ma innspecting the grounds of this ashram

Sri Anandamayi Ma listening to devotional chanting known as Kirtan

Sri Anandamayi Ma—Darshan

Hill stations are places that the English military and aristocrats, and later the Indians themselves, would go to get out of the summer heat—resort towns several thousand feet above the plains and the rice fields with cooler airs than in the hot Indian summer below. Guru Dev had spent time in Mussoorie and Maharishi had been there in his service.

Maharishi had been Guru Dev's personal secretary and occasionally shared stories from that time. One story that I recall hearing was that many people wrote Guru Dev asking for blessings, for health or good fortune, for example, in getting money to pay needed bills. Many wrote back later thanking Guru Dev for his benevolence, boons, gifts, blessings. Maharishi said to Guru Dev that he did not understand since he had never read these letters to Guru Dev, so how could Guru Dev have done anything to bless these people? Guru Dev replied, "It is the Department of the Almighty."

It was well-known that Hindus would often make huge offerings of not only fruit or flower to gurus but also even large sums of money. Guru Dev refused to ac-

cept any money. He plainly stated that he would accept only your sins and suffering—but then, as Maharishi explained, you could not take back your sinning and previous ways.

On a particular day, our small band assembled to contract with taxis to take us to Dehradun and the fabled hill station of Mussoorie. I remember wending down roads, across valleys, and then winding higher and higher into the mountains. First we visited an ashram of Anandamayi Ma in Dehradun.

When we visited the first ashram, we saw Sri Anandamayi Ma sitting on a dais with male and female disciples sitting, singing and chanting to her. The form of music is called "kirtan"—devotional chanting. We sat on rugs on the ground, two-thirds of the way to the back. I felt oceanic waves of bliss emanating from her—as if she were both the placid ocean and she could move the ether in waves of joy. I had never felt anything like that. Her divinity was enormous. In 2014, I visited her Samadhi (place of final burial in the form of a monument) in Hardwar and felt the same huge waves of divine bliss.

Sigmund Freud in his book *Civilization and its Discontents* posited oceanic feelings that were the foundation of all religions. He confessed that he had never felt them and was unsure of their existence. What we had witnessed around Anandamayi Ma was ineffable.

We stayed about an hour, or more, as she sat listening to the chanting. Then she gave a short discourse, no one word of which could I understand. She then arose and went to her car and was driven to her next ashram.

We raced to our taxis and rushed there. The taxi driver must have known where to go. High above the plains, we came to a gate barring the way across a high mountain pass, with a toll collector. There was a multilingual sign in English, Hindi and pictograms specifying tolls to pass. There was one toll for a person on foot, another for a bicyclist, and different fees for each of cars, trucks, taxis, elephants, oxcarts, camels and so forth. It was like nothing that I had ever seen; it is engraved in my memory—the black carved letters on the gray wood with all the different manner of animal, mechanical and human transport. We crossed over the trail toward the hill station.

When she arrived we were already standing there. We had flowers to give

Sri Anandamayi Ma

her. (What do you give to a saint who has or is everything? A flower. How do you request the gift of their attention? Give them a flower.)

She said why are you here (or some such). We said, "We are from Maharishi." She said, "Is he here?" She was very excited at the prospect of seeing Maharishi. We said, no. She said, "A great saint and teacher." That was most gracious and heart-warming. We felt welcomed.

She walked around her grounds and gardens with the stature of a divine personage. She was telling her people how to groom the garden and what to do. In that she exactly reminded all of us of Maharishi, lordly, statuesque, a master of all he or she sees, yet without pretense, down to earth in dealing with details, and interested in every detail of everything she surveyed including landscaping. Just like Maharishi, she was directing gardening, pruning, and organizing the landscaping of the grounds in great detail.

We were blessed to receive her esteemed darshan. In the cases of Maharishi, Tat Wale Baba, Anandamayi Ma, to be in their presence and to see them was to discover to the best of one's abilities what they taught, what they believed in, and who they were. There was something about each of these people that was strikingly similar to the other two—power, brilliance, huge peace and crackling intellectual and spiritual energy—something quite different.

CHAPTER 6

SOUTH INDIA

"A sannyasi suffers while a yogi enjoys."

- *Maharishi Mahesh Yogi*

As Maharishi promised to me in his garden, I stayed on in April of 1970, after the course ended. Summer comes early in this part of India. Winter lasts to early March and then suddenly it is summer. From April to June it's very hot, and then the monsoons arrive. It's said that the rain strikes with such force as to bounce off of the parched earth.

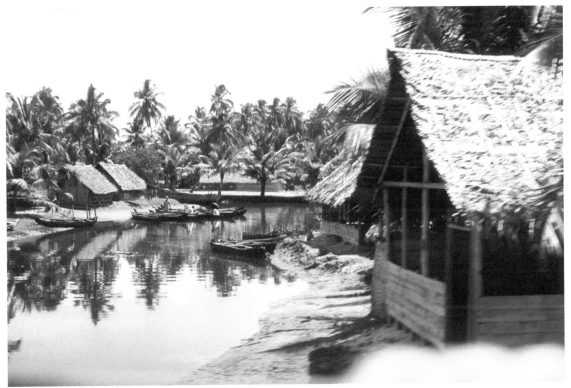

Backwaters of Alleppy, Kerala, from our taxi

Scene from our taxi of a village by a river in Kerala

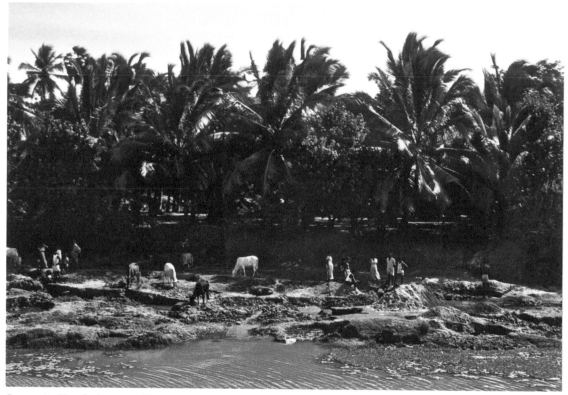

Scenes in Kerala from our Taxi

What followed for me was several weeks of unmitigated joy. Every evening we would sit on Maharishi's roof in the balmy breezes. Maharishi's discourses were informal and warm. When the time came, we traveled to Delhi, stayed overnight, and flew via Hyderabad to Bangalore, which was deep in the South of India.

Although the Aryan tradition of India is embedded in the North, it was intimated that the South of India, the land of the Dravidian culture, had better maintained the ancient traditions.

Bangalore was then a small, lovely, inland city, with graceful roads, gracious people, and flowers and gardens everywhere, the Garden City. Now it is a huge city, the Silicon Valley of India. I remember bus and taxi rides, seeing flowers in the rotaries and by the sides of the road. One time I did get sick with a bout of dysentery but one traveled with Imodium or its equivalent, Lomotil; traveling was always a risky time.

Maharishi had taught meditation in Bangalore in the later 1950s, and this was his first return, over ten years later, to follow up on the progress of his students, and to teach those who wished to teach meditation. My traveling companions were several of Maharishi's brahmacharis, dignified, proud, warm and accepting of

Temple in South India

85

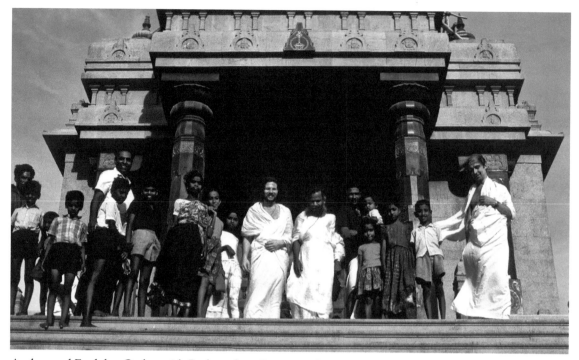

Author and Fred den Ouden with Brahmachari Sattyanand.
We are dressed in dhotis, to the amusement and pleasure of local people.

us, as well as Brahmachari Sattyanand and a few westerners.

The lectures took place in an old school and we—who had just completed the teacher training course—acted as assistants. Maharishi would have us speak briefly from time to time. One time, I recall Maharishi was going to ask one of us to introduce a topic, and Maharishi looked at me, but at that exact moment Geoffrey Baker began to say the exact words that were in my mind. That was odd. Maharishi looked quizzical.

One evening Maharishi indulged the audience with tales of his master, Guru Dev, Swami Brahmananda Saraswati Maharaj, Jagadguru of Jyotir Math. Maharishi told stories of how people were mesmerized by his words, enthralled, inspired to give up sinful and harmful ways, although his words were always brief. Maharishi talked of Guru Dev living in the forests and jungles near a cave with running water, near food such as roots, nuts and tubers, and animals not fighting within a mile of his solitude. These stories are recounted by Maharishi in the Introduction to his book of poetry, *Love and God*. As Maharishi spoke, the professional tape recorder with which I was recording simply stopped. After Maharishi returned to matters

regarding the course, the wheels of the recorder began turning again.

After a couple of weeks, as the course drew to a close, Maharishi suggested that his brother monk and our friend Brahmachari Sattyanand tour the places in South India where Maharishi had started the TM movement and that Fred den Ouden, a photographer from Holland, Geoffrey Baker, an artist and art professor from the U.K., and I accompany and aid Sattyanand.

A few days later the four of us set out for Alleppey, the Venice of South India. The scenery through the windows of the taxi was lush. This was the province of Kerala, which means coconut. The coconut provides everything that a family needs to live: shade from the tree and fronds; coconut milk to drink; coconut meat to eat; and fiber for clothing and shelter. It is symbolic of the perfect plant and the wholeness of life.

When Maharishi surrendered to and lived with Guru Dev, he rose through the ranks of attendants and became Guru Dev's personal secretary. When Guru Dev passed in 1953, it is said that Maharishi retired to Uttarkashi, the Kashi (Varanasi) of the North, called the "Valley of the Saints," in the Himalayas where he lived in

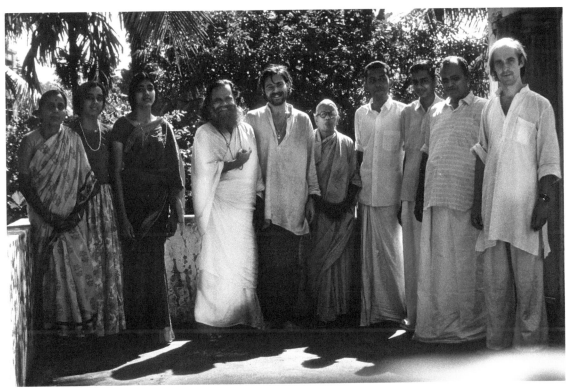

Grateful guests of gracious hosts.
Author in center with Brahmachari Sattyanand. Fred den Ouden on right.

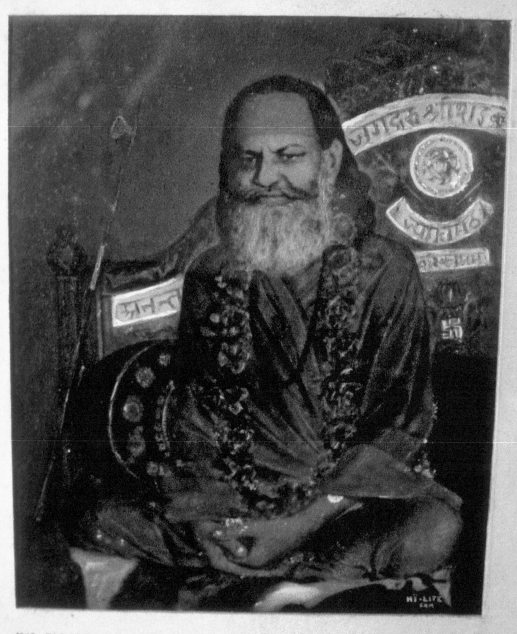

HIS DIVINITY ANANTHA SRI VIBHOOSHIT BHAGAVATH POOJYA PADA
SWAMY BRAHMANANDA SARASWATHI MAHARAJ THE LATE JAGATGURU
SANKARACHARYA OF THE JYOTIRMUTT - BADARIKASHRAM - HIMALAYAS

Portrait of Guru Dev from the 1950s

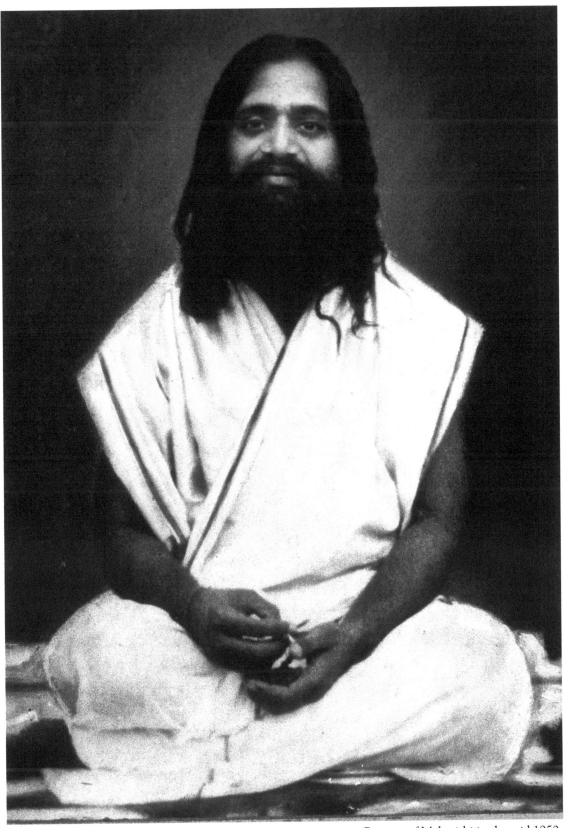

Portrait of Maharishi in the mid 1950s
Most likely a black and white photo that was hand-colored

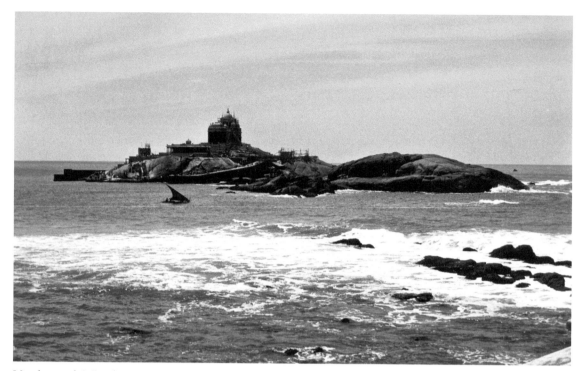

Vivekananda's Rock at Kanyakumari where the Bay of Bengal,
The Indian Ocean and the Arabian Sea meet.

solitude for several years. I have been told that Uttarkashi has grown, and lost some of its solitude, but it may be inaccessible at times of the year and requires either a treacherous drive, a donkey ride, or preferably a helicopter to visit.

There are stories of his living in a basement or a cave and being brought simple meals. Maharishi recounts that there was a saint who lived there who was his friend. They would meet from time to time, perhaps months apart, and sit, enjoying each other's company and gazing out at the high Himalayan peaks above, and the Ganges River below. There was a saying then that life was simple and good where they were, but around the bend of the Ganges was the entire world of mud.

Maharishi said that from time to time he would get a thought to go to South India. He mentioned this to his friend who recommended that he go, to get the thought out of his mind. In 1955 Maharishi did travel to Rameswaram, Kanyakumari, and then Alleppey, in Kerala, South India. There he agreed to give lectures on meditation and then in Trivandrum, after several lectures, he announced that with this simple technique of what he then called Transcendental Deep Meditation, he would spiritually regenerate the world. He stated that he was surprised to hear himself say this, but he recognized that this was his duty to his teacher, and his calling.

Sunrise at Kanyakumari over the Bay of Bengal

The analogy for meditation he then used was that the juice of the orange was sweet but the skin was bitter. You could poke the orange with a needle so the inner juice would flood the outside of the orange through tiny holes This was the innermost value of life coming to the surface of life: The experience of Pure Consciousness floods the mind and the outer values of life with sweetness.

As recounted by Jerry Jarvis* and also by Maharishi: Maharishi in 1955 traveled to the temple in Rameswaram in South India. Then he visited the temple at Kanyakumari. He meditated there for five days. He stated that he experienced why the temple to Mother Divine is there. Maharishi then started to return to the Himalayas.

Maharishi explained that he had a faint thought: why not give some of the knowledge to the people here. When he got to Trivandrum, a man approached him and said you must be from the North. "Why not give some some wisdom from the Himalayas?" (In the North, the dhoti is worn full length. In the South of India, a garment similar to the dhoti, called the lungi, is often hiked up from the ankles and tucked in the waist. Thus the difference in appearance.)

* A debt of gratitude to Jerry Jarvis who recalled in perfect and gracious detail the early history of Maharishi's travels in India.

Sunrise, Kanyakumari

Sunrise, Kanyakumari

Maharishi said, I don't lecture. The man said I will arrange for you to lecture. Maharishi said give me some titles. The man gave him seven titles. It is assumed that Maharishi began teaching at this time, perhaps the first night. He would give a talk and initiate those who wanted into the meditation practice. There is a library in Trivandrum where Maharishi gave his first seven lectures. Maharishi traveled north to Quilon, Alleppey, and Ernakulum, now called Kochi or Cochin, teaching his Transcendental Deep Meditation practice.

After three years of teaching around India, and seeing that the results were beneficial to thousands of people, in the Introduction to Love and God, Maharishi said that he was directly inspired to by Guru Dev to announce the Spiritual Regeneration of the world.*

We visited Alleppey and then following Maharishi's path in reverse we traveled to Trivandrum. There was a temple in Trivandrum which had a sign indicating no westerners were allowed, only Hindus, or some such. We thought that since we had just spent months meditating in the Himalayas in Rishikesh with a guru, that

* H.H. Maharishi Mahesh Yogi, *Love and God* (Maharishi International University Press, Los Angeles: 1973) p. 11.

Sunrise, Kanyakumari

since we were respectful and not touristy, we deserved entry. We promptly bought traditional dhotis, wrapped ourselves in white robes, and started visiting all the temples. We were bold.

The reader needs to understand that in India there are diverse races, and multiple languages. At that time, because people in different regions could not communicate with each other, English was the most common language in India. There are 18 languages in India older than old English, and countless dialects. In the north, people are Aryans—populations that in times immemorial had passed from Turkmenistan, Afghanistan and the Middle East to India. In the South were the Dravidians, whose heritage probably goes back 50-70,000 years, perhaps to the-beginning of human time. Therefore it was reasonable to assume that if we said in English that we were traveling from the Himalayas, there was no reason to assume that we weren't. And of course, we were, and we were accompanied by a legitimate holy man, who had nothing to say except with a laugh and smile.

Sattyanand was both amused and horrified. As you might see in the pictures, my traveling companions and I do not quite look authentic, but India is a huge

Sunrise, Kanyakumari

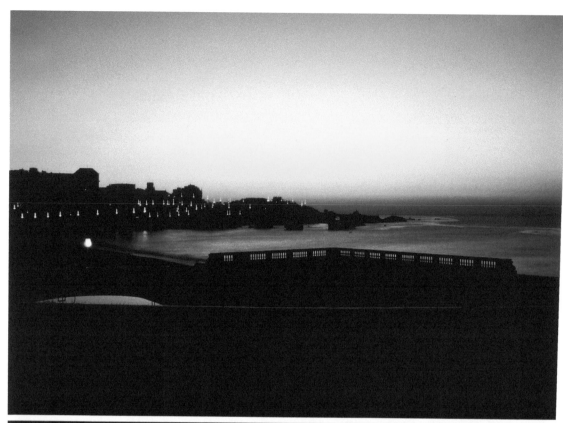

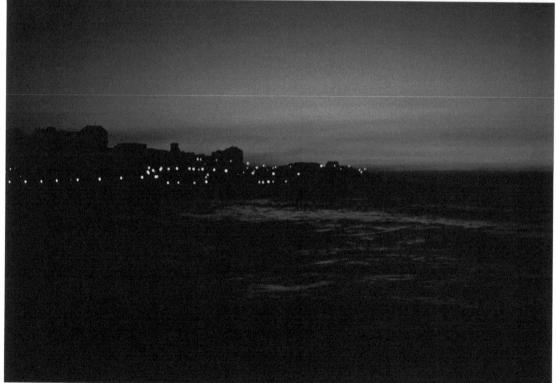

Sunset, Kanyakumari

country and, as said, with a diversity of cultures. Since the Dravidians in the South are very dark, and there are others in the North who are not, clearly we must be from North India.

We Westerners had straggly beards, longish hair, but clean, white dhotis. However, we were inexpert in wearing them and were constantly catching and re-adjusting them to keep them from falling off. Of course natives also have this challenge. You will still see men on the streets readjusting their dhotis. After a while, we became proficient. Returning to India after 44 years, I was told that I wore a dhoti well. I guess one never forgets.

It could be said that we were irreverent; however, we were sincere in honoring the true intent and meaning of the culture and the religions, as evidenced by our commitment to spiritual knowledge and to meditation. Perhaps impertinent? The days of relatively easy access to temples are currently gone. Now there are armed military personnel asking to see a certificate of nationality at some of the great and famous temples, although village temples are still accessible, charming and authentic in the best ways.

In Kerala, I found an old picture of Maharishi from the mid 1950's, prob-

Sunset, Kanyakumari

Shiva Lingam in Temple at Rameswaram

ably about 40 years old or younger. I located an old booklet called *Beacon Light of the Himalayas* in which Maharishi laid out his philosophy of Transcendental Meditation filled with testimosials and endorsements or Maharishi's revival of the pure Vedic teaching. It is entitled the *Dawn of a Happy New Age* and it is by "Maharshi Bala Brahmachari Mahesh Yogi Maharaj of Uttar Kasi, Himalayas." Bala-brahmachari means life celibate, and Uttar Kasi (Uttarkashi) was his previous residence, to which he had hoped to return and to which he never did. This historic tome can be found on the Internet.

As we were traveling, we stayed with local families at first. These must have been people who had supported and loved Maharishi in the 1950s. In Kerala, people speak Malayalam, perhaps Tamil or Telugu, too, or Hindi, but not English. Conver-

sations were minimal. Now I realize the great lost opportunity for historic stories. It was fairly difficult to guess how to adapt to the daily mores.

I learned the hard way that, while we were taught in the West to finish what we were served, whether we wanted to or not, in India it is a sign of respect to leave food on your plate to indicate that your hosts have satisfied your every need. I almost ate a few families out of house and home until I learned this custom by inference—each of us trying to be polite under the rules of our respective cultures, 12,000 miles apart. I would sit on the floor, cross-legged, unable to get up, fearful of offending, as more and more food was shoveled onto my plate or plantain leaf, as the host wondered if he would run out of staples.

Our hosts were always kind and gracious, treating us with far more respect and warmth than we were due. Of course, that is the Indian culture of treating the guest as God. We were from Maharishi and in the company of Sattyanand, a saint. An ancient Upanishadic saying states: Treat Mother as God, treat Father as God, treat Teacher as God, treat Guest as God.

Another time, we were invited to bathe. I found a giant tub of clean water in the grassy, sunny yard. By giant, I mean perhaps five feet tall and five feet across shaped like an amphora. Undoubtedly, it was filled by hand, probably by family

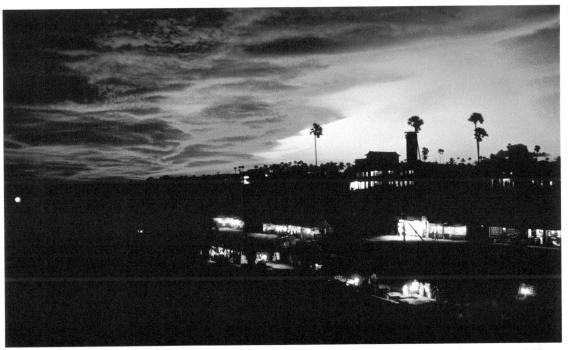

Sunset, Kanyakumari with Streets and Shops

99

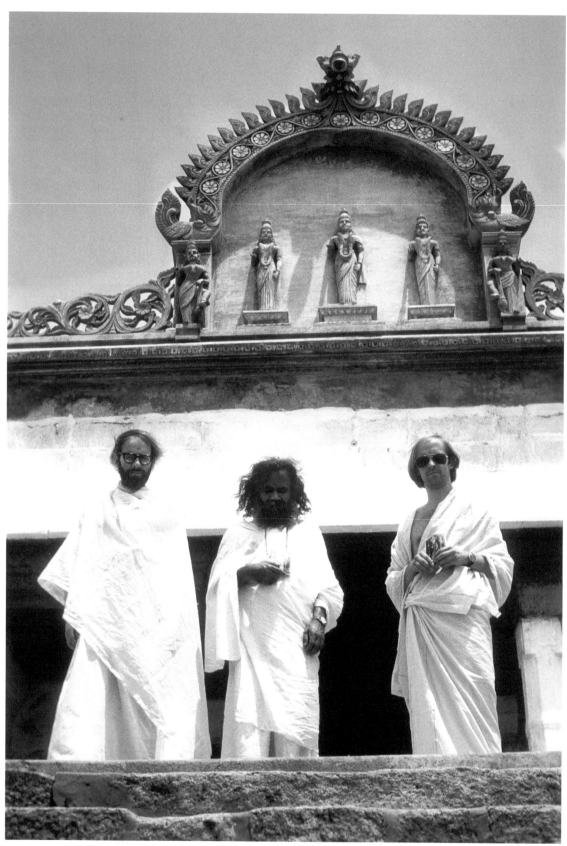

Geoffrey Baker, Brahmachari Sattyanand, Fred den Ouden

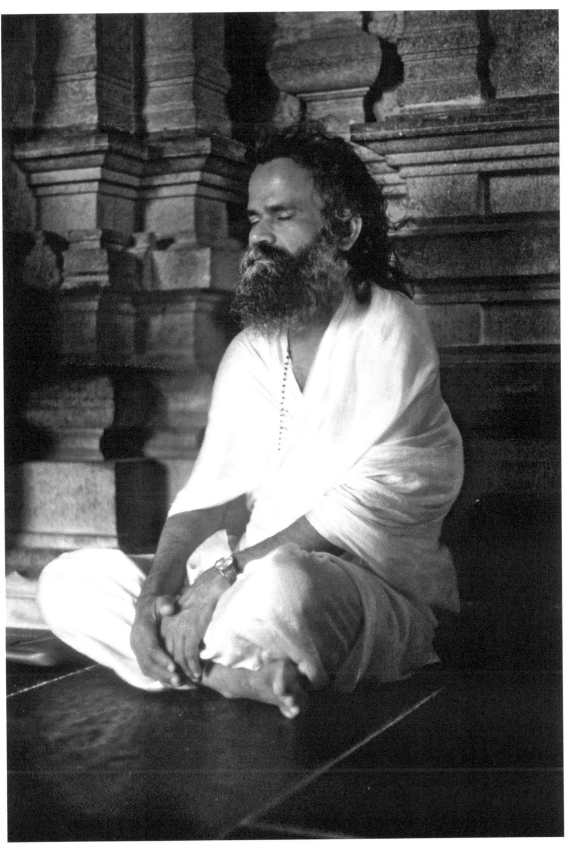

Brahmachari Sattyanand meditating in the solitude of the temple

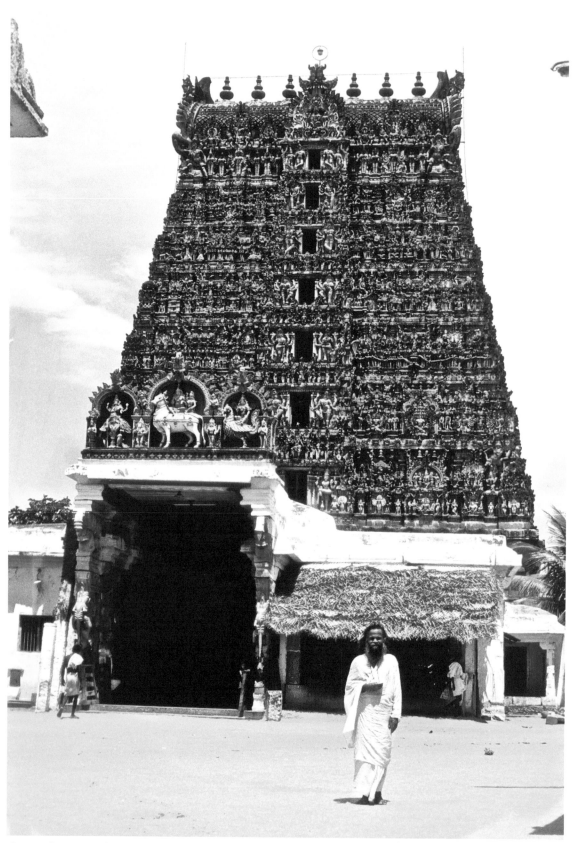

Swami Sattyanand at Rameswaram

Detail of ancient temple at Rameswaram

or servants carrying jugs of water, on their head, from a well to the tank. I almost jumped in. Or did I jump in? I'll never say. Then I realized that there were bathing cups with handles intended to be used to pour the water on your body and thence into the garden.

The naivety was not entirely ours. One time someone asked me where I was from and when I replied, "the United States," they began asking me if I knew a litany of people. Given the size and population of the United States, this would have been highly unlikely and I did not.

You can see in one picture, Sattyanand laughing at me doubtless after one of my foibles. Sattyanand was a kind, patient, forgiving, and generous traveling companion, and the four of us got along extremely well even when we westerners were exposed to what we considered hardships by our pampered standards.

Clockwise from top left: Sri Ganapati, Mother Divine, and other ancient temple religious art

People at the train station

My traveling companions were a constant joy. Fred den Ouden, although not a big man, had a ready, huge, baritone Dutch laugh. I watched as he juggled cameras taking pictures out of taxi windows, holding the camera over his head, snapping away constantly. I learned from watching him, without a word said, about some things in the techniques of a professional photographer. Get the picture!

Geoffrey Baker, a bit more quiet and restrained, displayed a warm and gentle wit. Older and wiser, he was an art professor, and an artist, in England. He confessed that George Harrison of the Beatles used to 'pop over' his house unannounced to talk about meditation and meditate with him. He said George was a lovely fellow. At 22, I was the youngest, a bit impetuous, less worldly.

We four, Geoffrey, Sattyanand, Fred and I, traveled to the tip of South India, Kanyakumari, formerly called Cape Comorin by the British. At Kanyakumari three seas meet: the Bay of Bengal, the Indian Ocean, and the Arabian Sea, where ancient dhows sail the seas, and fishermen fish for local catch. We watched the sunrise and later the sunset over the oceans. We bathed in the tropical waters. It was most glorious and magnificent.

The town of Kanyakumari was then small, a few shops, a few restaurants, and

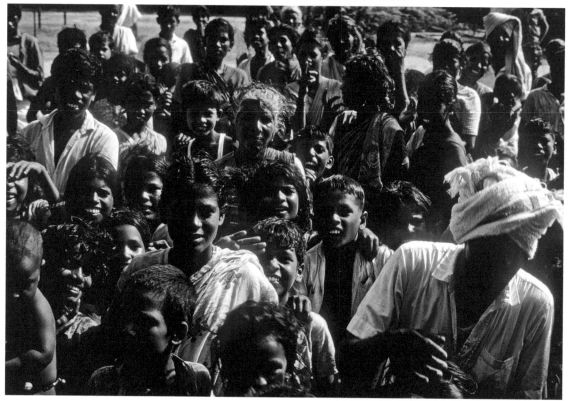

Top: On the street
Bottom: Received great good will at a village train station en route to Rameswaram.
Babies were handed to us and immediately returned by us.

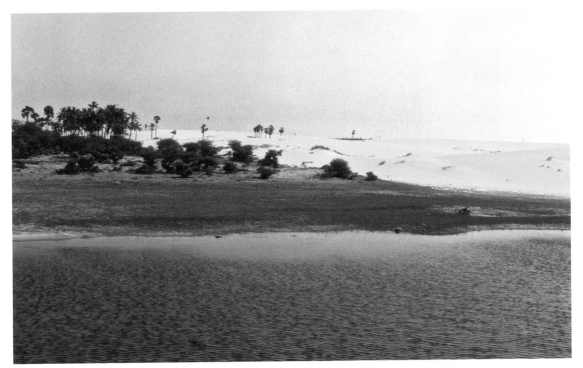

Settlements and villages on islands near Rameswaram

a few simple places to stay. In restaurants we learned how to sit cross-legged on the ground and eat South Indian food, spicy-hot veggies, lentils and rice, served out of stainless steel pails with stainless steel scoops and poured onto plantain leaves used in lieu of plates. We had iron guts but even so, sometimes the temperature of the South Indian spices was more than any of us could bear. So we would drown the fires in lassi-like yogurt-curds only to find that the lassi was saturated in hot spices with chili peppers, floating majestically, triumphantly.

Typical South Indian food includes dhosa, which is a crispy, thin, rice bread; idlis, fermented rice cakes served with various chutneys, some hot, some nutty or coconut; and different vegetable dishes, each hotter and spicier than the last. We ate with the fingers of our right hands as was customary. I being the youngest probably had the most to learn, but the easiest time of the Westerners.

Kanyakumari is the ancient site for Mother Divine, before she was married, that commemorates her marriage to Lord Shiva. There is a magnificent temple, adjacent to the water's edge.

Now intimately familiar with and confident about our Indian garb, we visited the inner sanctums. No one minded. We soaked up the peace, joy and sanc-

107

One of the 22 tanks at Rameswaram

tity. We meditated in the cave-like chambers. Priests were blowing the ceremonial horns in prayer, the shehnai, loud, clear, brilliant, melodious, reminiscent of the immortal Coltrane. Outside the oceans were rough and magnificent.

There was a rumor floating around the Academy that when Maharishi had visited the temple at Kanyakumari at the coldest times of the Cold War, he had pled with the Divine Mother not to destroy the human race. Of course, humans could still self-destruct. In the 1950s, the global fear was nuclear annihilation. Now more

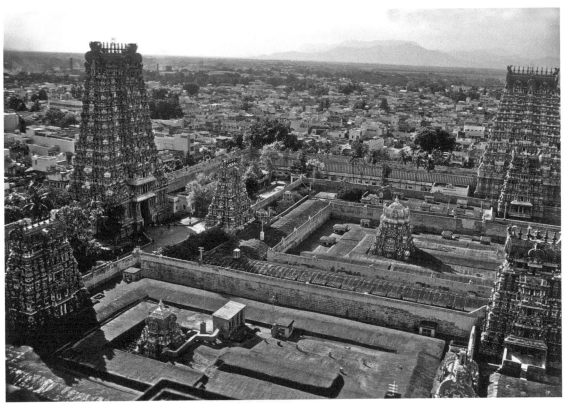

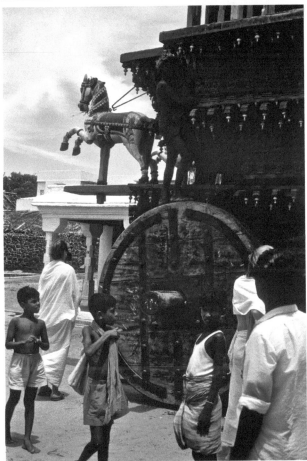

Top: Giant temple complex of
Amman Meenakshi at Madurai.
Left: Geoffrey inspects the
ceremonial cart at Meenakshi.

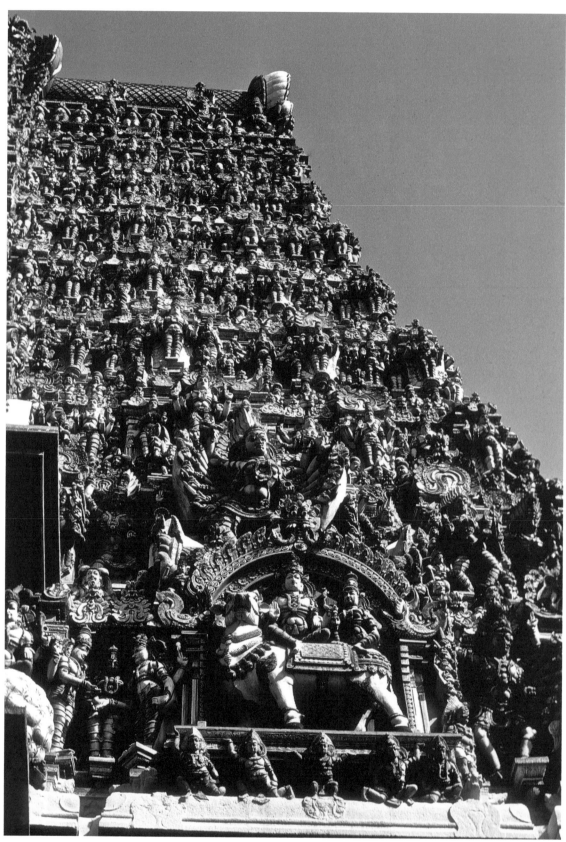

Ten towering gates, some nine stories tall, thousands of statues—the detail at Amman Meenakshi Temple.

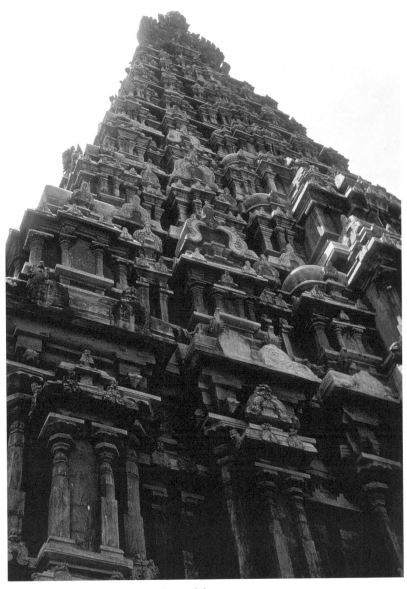

One of the towers

than half a century later in the second decade of the second millennia, annihilation of humans at their own hands is again a topic under the rubric of anthropogenic climate change causing drought, famine, abhorrent weather patterns, along with commensurate destructions of the ocean through the triple threat of warming, acidification, and concomitant deoxygenation even without regard to the destruction of the fisheries. That is not-fetched. Studies indicate that there have been more than one tribe or species of humans, and that the human population dwindled to a few thousand about 70,000 years ago. Our hold on this planet is tenuous.

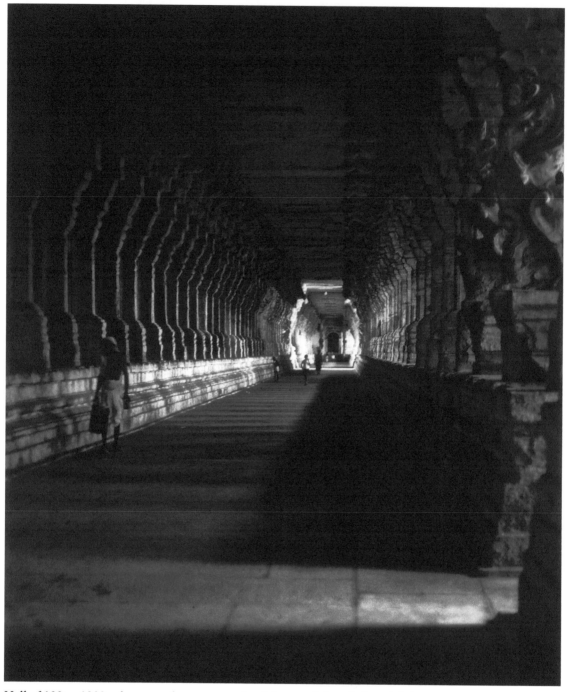

Hall of 100 or 1000 columns at the great temple of Amman Meenakshi at Madurai.

We spent time climbing around the town to observe the sunrises and sunsets over the ocean. One of my favorite photos was taken during a crimson-coral, opalescent sunset with shops lit on dark streets and the sky blazing like the gates of heaven. René Magritte, painter of *The Empire of Lights*, might have enjoyed. My light meter was inaccessible and somehow using mental mathematics, guessing and

Left: Museum within the temple
Right: Maintenance of a living temple

luck, I was able to get that one shot at that moment.

We departed Kanyakumari and traveled by train to Rameswaram. Although Kanyakumari is on a peninsula, Rameswaram is an island. The train at that time crossed an long ancient bridge which was one of the only forms of ingress and egress.

Rameswaram is considered to be one of the oldest settlements and temple sites in India. This is where Hanuman, the great and loyal Monkey God, leaped across the ocean to Sri Lanka to rescue Ram's wife, Sita, who had been kidnapped by the demon that lived and ruled there. The story is told in the Ramayana.

Debarking from the train, we traveled by oxen or bullock cart. We purchased bamboo mats and used them as beds. It was not a penance. Actually bamboo is quite comfortable, even on a concrete floor. We Westerners grumbled a little at first, but hearing that Sattyanand never had a word that was less than cheerful, we soon adapted.

Detail of temple gate

The temple in Rameswaram seemed enormous. There were twenty-two "tanks", where water is stored in various forms. Some were in wells that descended thirty to fifty feet, some in pools surrounded by stairs in the form of concentric rectangles, some in springs. Each represented a different holy river of India, the blessings of which could be tapped by bathing or chanting. Sattyanand, being a true, religious Hindu, engaged a priest to do prayers and ceremonies at each of the twenty-two tanks. The priest would chant mantras or prayers and then pour buck-

Tallest tower at temple of Meenakshi is 170 feet high

ets of water over Sattyanand's head at each tank.

Geoffrey, Fred and I tagged along and were blessed by being inundated at each tank. It was great. It felt very good. It made us laugh and feel happy. The temple has a wonderful air of sanctity and peace with the dank moss of the cool pools under the intense tropical heat of the South Indian summer.

Just behind the temple, on the side away from the main street, there is a beach on the Bay of Bengal. Sattyanand engaged a priest to do a special ceremony,

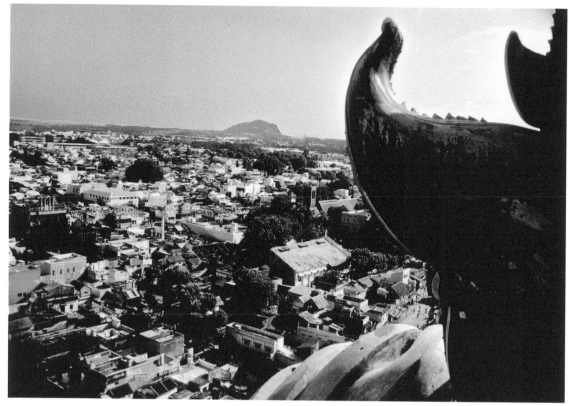

View of Madurai from the top

perhaps to Rama, on that beach at dawn. We tagged along. It being for Sattyanand's benefit as far as we could tell, and the chanting being in a foreign language, we could not understand any of the words or much of what took place, but we loved being there. Sattyanand was devout and disciplined. He rose early each morning well before the sunrise to do the meditation practices taught to him by Guru Dev and by Maharishi.

Sattyanand was a brother monk of Maharishi's. He had been married when he had met Guru Dev as a young man. When his wife died early, and since he was without children, he left the world of business, and joined Guru Dev's entourage in his monastic order. Sattyanand explained to me that Guru Dev was a true world spiritual leader but even at that time, it was clear that Maharishi was the path to Guru Dev.

We were never formally tasked with being Sattyanand's companions and caretakers, but we naturally found that we looked after him, carried his things, and tried to ensure his comfort and safety. We did all that quite naturally without any

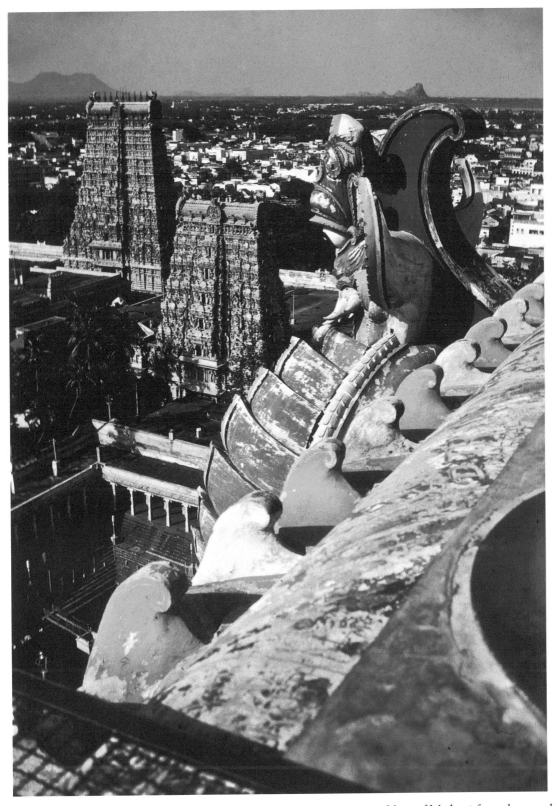

View of Madurai from the temple

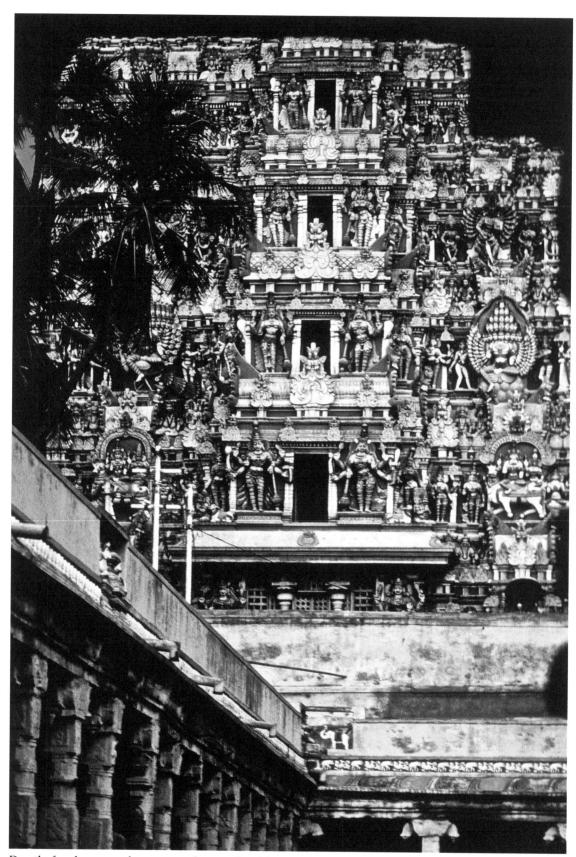

Detail of sculpture on the tower at the temple of Amman Meenakshi

Detail of sculpture on the tower at the temple of Amman Meenakshi

need for further word or consideration.

We discussed going to various other temples and cities, but Sattyanand determined that our last visit would be to the temple of Meenakshi in the town of Madurai. We tried but could not procure first class tickets on the train. The experience was culturally transcendental. There appeared to be whole families living, dying, being born, cooking, and sleeping in the train stations. The train was ancient and wonderful with wood panelling and brightly dressed people crowded closely together. We eventually got a compartment to sit in and we peered out the open windows endlessly.

There were huge crowds at the train stations along the way and when they saw Fred, Geoffrey and me, strange white people dressed in dhotis, they assumed we were powerful saints. We had no such illusions. They handed us their babies in swaddling through the open train windows for us to bless! Not knowing what to do, we immediately gave the babies back! Sattyanand could not stop laughing.

The trip to Madurai was arduous, with first a train ride, and then a bullock cart from the train station to some kind of residential place. The Indian equivalent of a low budget motel is a room with a floor and communal toilets and sinks. We slept on the floor on our straw mats in an establishment on a small street near the temple.

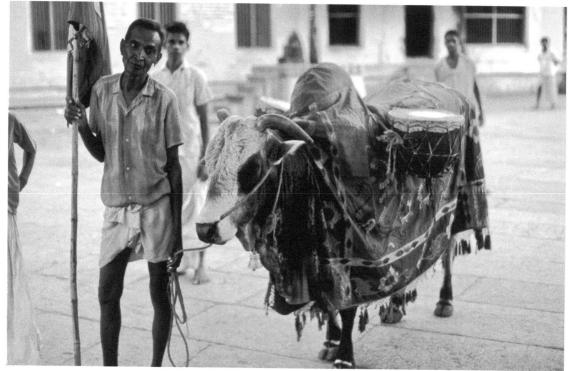

Brahma bull in ceremonial garb

Madurai looked like an exotic old west town from 50 or 100 years ago. There were primitive vehicles, motor carts, and trucks blindly clattering down the street at unsafe speeds, camels, bullock carts, pedestrians, bicyclists. It was a wonderful and disorienting place.

The temple complex was enormous. You entered through portals where hundreds or thousands of shoes and sandals were stored. There are ten gates, high towers, each story carved with legendary and mythical characters, gods, demigods, demons, and what not. There appeared to be thousands of carvings. It could have appeared ancient or at least medieval but it was a functional site, the buildings and carvings kept in wonderful color and repair. It was breathtaking.

There are inner sanctums, areas where ceremonies are performed, where the statues of the Gods are kept. There is a hall of 1000 columns. Once while wandering alone down this dark, long, temple corridor, a stately and dignified elderly man with noble carriage, longish white hair and beard, dressed traditionally in a dhoti, approached me and spoke in English. He asked me who I was. I answered, as I always did, that I was from Maharishi Mahesh Yogi in Rishikesh, Himalayas. He asked if there was anything I wanted. Feeling both shy and yet fulfilled, I said, No,

120

thank you. Afterwards I felt I had been blessed.

We spent our time divided between exploring the temple grounds and sacred spots and meditating in the quiet areas. In the huge complex, there were many places to sit and close the eyes. Again, we heard the haunting sounds of the shehnai.

Outside the temple, the food was several degrees hotter than imaginable. One time I found the temple elephant, a baby elephant wandering about. I was invited to sit on the willing elephant's back and enjoy a ride for a modest donation. I sat astride her neck and she walked as far as her chain would allow. She was very kind and accommodating. She extended her right leg, and lifted me onto the back of her neck. I also learned that the bristly hairs on the back of the elephant's neck were uncomfortable when you ride essentially bare-legged in your dhoti.

Outside the temple of Amman Meenakshi, the formal name of the temple in Madurai, was a giant wooden cart, which was drawn by the multitudes around the city at times of festival. After several days, it was time to leave Madurai and head to the town of Madras to fly back to Delhi.

It was a surprisingly long trip back to Delhi and then Rishikesh. We loved

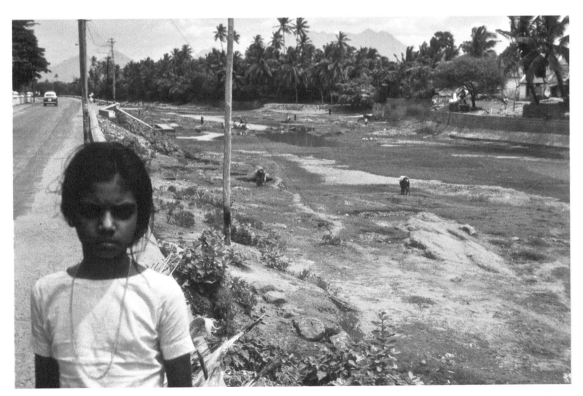

Girl by the side of the road

121

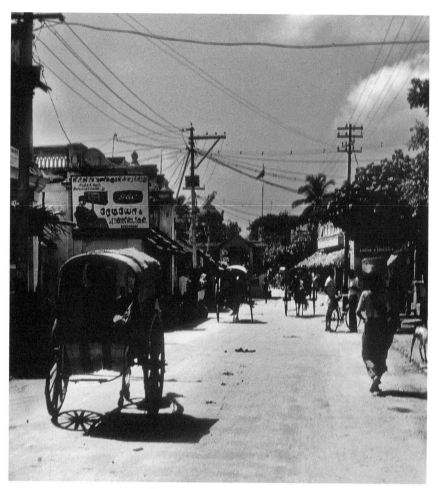

Village of Madurai circa 1970.

the south of India but missed the comfort and familiarity of Maharishi's Academy which was Sattyanand's and now our home. All modes of transportation were deployed, bullock carts, trains, and airplanes. I recall images of people in bright clothing, purples, golds, pinks, flowers everywhere, animals on runways, and clerks and bureaucrats who made things easier for a swami accompanied by seekers.

In Delhi we hired a taxi to drive us through the hot, dry North Indian summer up to Rishikesh in the valley of the Ganges in the foothills of the Himalayas. It sounded so good. Whereas my first trip to Rishikesh was frighteningly fast, this last one was shockingly slow. During the 125 mile journey, our taxi overheated, then thoroughly broke down in a small village along the way in a flood plain, before we reached the Ganges and began the ascent into the foothills.

The town mechanics at the local garage told our drivers that it would be two or three days to get the parts to fix the taxi. There were no alternatives. We found

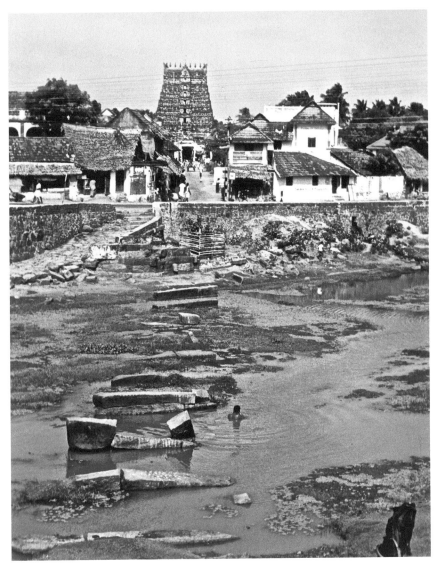
Village temple by a river

a simple rooming house and obtained a second floor room. Four walls, a floor and roof with some open eaves. The toilet was a hole in the outside wall with a spigot for water to fill a pail on the floor for hygiene. It took courage to walk around the house and find how the hole in the wall drained into a shallow ditch above ground. Contemplation of the third world infrastructure gives one pause for compassion and motivation to change the world.

Geoffrey, Fred, Sattyanand and I spent our time sitting under trees in the shade, meditating, relaxing, enjoying conversation. There was not much else to do. The people were very nice to us. On one particularly hot day, with temperatures soaring above 104°F (40°C), I recall being brought watermelon to soothe our hun-

Inner sanctum

ger and provide relief from the heat. Imagine our surprise to discover that each slice had been garnished and adorned with chili peppers and chili powder. Local medicine indicated that hot spices help digestion to battle the heat. Fight fire with fire. It made our mouthes burn and us roar with laughter.

Everything was new and unusual and actually delicious. And spicy. And colorful: Green chili peppers floated in the soothing yogurt and red-pepper doused watermelon. Days later, we arrived back at Maharishi's academy after dark, very hot and thirsty and tired. It was quiet. We had missed dinner.

After cleaning up, I stumbled back to the kitchen to get a drink of potable water. The door was locked. I shook the handle thinking that the door would just

open. No two doors were the same, all were handmade and unique. Some were a bit flimsy. Instead, a pane of glass fell out of the shaky door and lacerated my right foot right down to the bone. I felt a stab of pain and shock and I realized that I was in trouble and that this was a very serious injury.

Remembering first aid, I sat down and grasped the wound on the top of my foot with all my strength to try to staunch the arterial bleeding. My friend Geoffrey found me first and got others to help. Sattyanand arranged an emergency taxi and I limped, with Geoffrey helping me, to a quonset hut in Rishikesh that served as the local jungle hospital.

Lord Krishna Dravidian style

125

Left: Temple Museum
Right: Inner corridor

The Sikhs are a religious subculture in India that are deeply respected and a bit feared. Each man wears his hair long, wound in a white turban, and by custom carries a knife. I always liked them. The Sikhs are strong, smart people and make very good taxi drivers and great surgeons.

A skilled Sikh surgeon operated on me that night, under the light of a kerosene lamp and with no anesthesia to ease my pain or medication for me. I recall how black the jungle night seemed to me. I remember as he tied the severed blood vessels that I felt excruciating pain and also a deep peace. My body was wrapped about me like a mortal coil around my inner being or soul, and I no longer needed my body. I began to float above my body when I saw a flash of light and a vision of Guru Dev, Maharishi's master, and I snapped back into my body. The surgeon told me that he had thought I was gone, but that eventually I had done very well.

I was carried back to my room just before dawn, with the loud sounds of the jungle reverberating. Monkeys howled, birds chirped and then a large crow alighted

Temple elephant adorned as a goddess to bless pilgrims

on my window to tell me how He, Yama, the Grim Reaper, had been diverted. Geoffrey Baker injured his back saving my life. He never spoke of it again.

During the few weeks that followed I felt ill and weak. I recognized that I had contracted an infection. Luckily my father had outfitted me with a supply of penicillin to take with me (as well as the amoebic dysentery medicines that I had needed earlier). I began a proper course of antibiotics and the infection began to clear.

My friends would drop by to visit me. They were comforting. I would fall asleep and the stress of the surgery would cause my leg and foot to shake which

would tear at the wound causing pain to wake me. My sleep was broken repeatedly.

The brahmacharis came by from time to time. Maharishi asked after me. Bevan Morris was extraordinarily kind and considerate, checking in on me daily, bringing me mangos to eat, one of my favorites, and sweets and food to help my healing and comfort. I will never forget his kindness, compassion and diligence. He never failed me. He is in my heart.

After a couple of weeks, I heard that Maharishi was leaving the Academy. I hobbled down to his house and he said to me, "Are you staying here or leaving with me?" For a moment that was a difficult choice. I did want to stay in India at the Academy. But what was the Academy without Maharishi? Nothing, really. And I may never know what would have been, but it was very clear that the choice to be made was to go with Maharishi. He was probably just asking if I needed more recovery time, I said, "I am going with you." Looking back, one never knows what might have happened had I stayed on in the Academy, but this was an idealistic and loyal response. Or at least so I thought. Maharishi said, "All right." He said that we would leave in a few days for Switzerland and then the Italian Alps and that along the way I should get a cane. After Livigno, we would go to the United States.

We traveled in a motorcade to some cities where Maharishi was greeted as the great saint he was, with crowds, adulation and excitement. I wandered off and found two canes, a lovely twisted wooden cane, and a more ornate black cane with a golden handle. I got both. Later, I discovered that the ornate black cane was a sword cane, which made me laugh.

We traveled to Delhi where the airport was crowded with travelers and the runway crowded by livestock and poultry, which caused flight delays. We departed at night and the next morning the plane refueled in Greece. It was astonishing after five months in India, to leave Rishikesh and Delhi, which were then yellow and burning under the hot summer sun and see the cerulean blues of the Adriatic and the Aegean.

The plane landed in Zurich, where peace was fiercely protected by soldiers with automatic weapons. From Cairo in January to Zurich in June, the world had not changed. Someone organized a cavalcade of rental cars and I volunteered to be a driver. After three days traveling with Maharishi, my foot felt 75% better after

languishing on a plateau of discomfort for a month.

As I drove, I tried to keep pace with the mad European race-car style drivers speeding in the caravan. Oddly, I could feel my right foot healing. Unfortunately I was also driving like a lunatic. What can I say? Nothing really. It appeared to work out. Since that time, I studied skiing, scuba diving, airplane piloting and became immersed in thoughtful, meticulous safety procedures and discipline, in all endeavors. Times change. An esteemed friend from then, Debby Jarvis, asked me a couple of years ago if I still drove like that (an idiot). I said, not at all. I explained I had become a pilot, ground instructor, scuba instructor, ski instructor, and had learned to be precise, alert, and careful. She appeared satisfied by that explanation, and pleased.

We arrived at an Alpine hotel for a three-week meeting with Maharishi where he convened all his teachers of the world for the first time. It was called an Advanced Teacher Residence course (ATR). Maharishi indulged his teachers with stories of myth and philosophy as well as teaching and inspiration. It was there, over a friendly and loving dispute about saving chairs, that I met one of my dearest friends, Morris Cohn, with whom I would take walks daily and who, when I moved to Colorado, I met with, often a few times a week, every week.

From Livigno, on the Italian-Swiss border, our group traveled to Poland Spring, Maine and Eureka, California (Humboldt State University at Arcata), each being a month-long course with Maharishi for interested TM meditators. It was in Maine that Maharishi informed and assured me that I would be returning to school in the Fall. I clearly remember as I had volunteered to do some task for him, always an opportunity and a blessing, that he said, "No, you will be in school then," and that was the plan from then on, reluctant or not.

CHAPTER 7

EPILOGUE

*"Enjoy 200% of life: 100% inner spiritual
And 100% outer material"*

- Maharishi Mahesh Yogi

I had met two brilliant and inspired sociology professors at Poland Spring, Kingsley Birge and Stephen Marks, who became my academic mentors and friends. They decided they wanted a TM teacher at their school, Colby College,

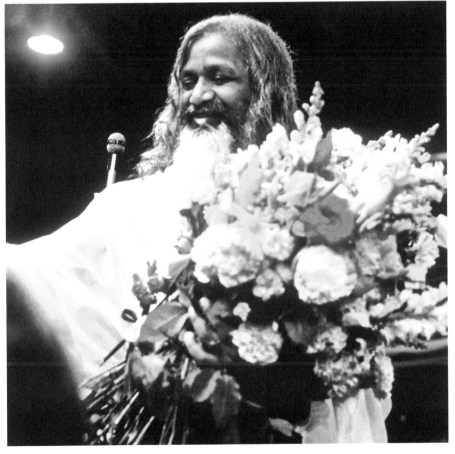

Maharishi returns to the USA

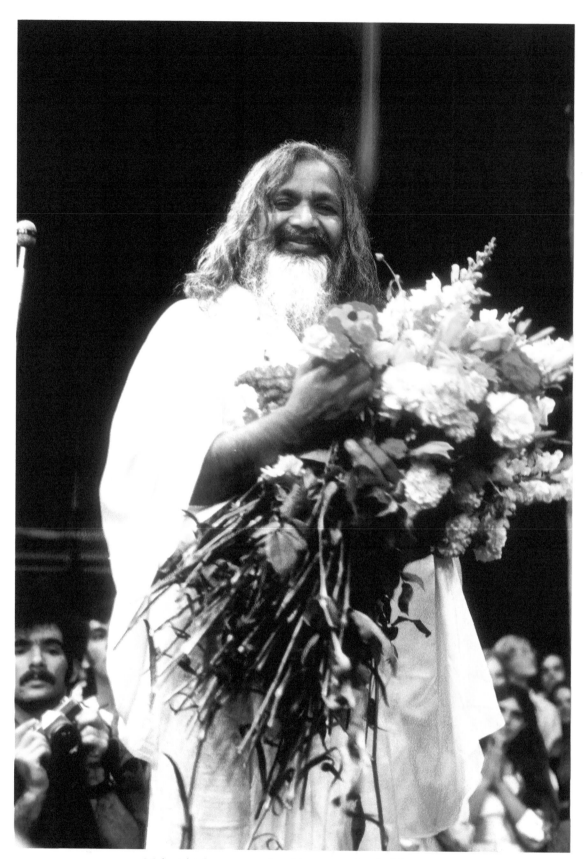

Maharishi draws a crowd and is given individual flowers.

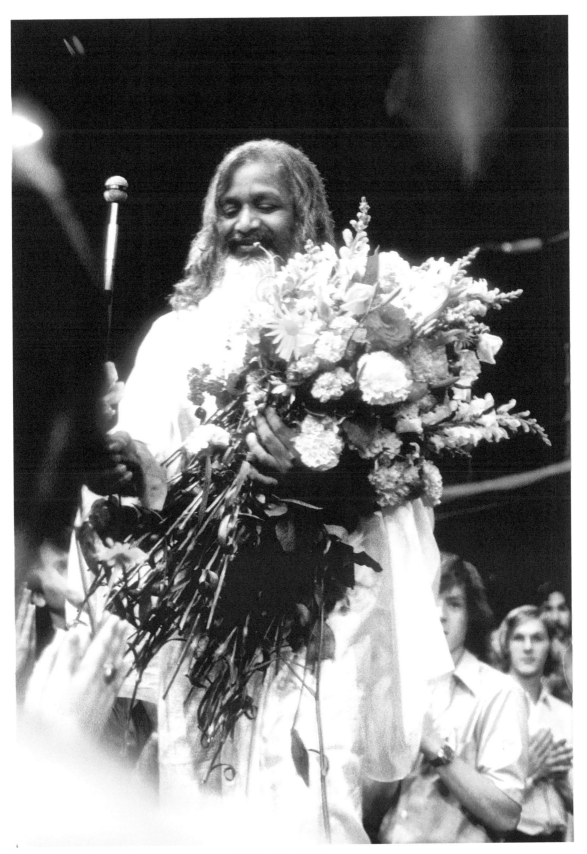

Maharishi with flowers.

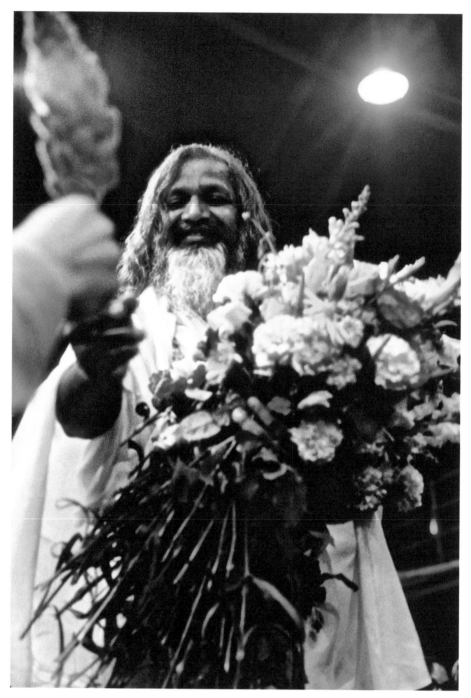

Maharishi receives a flower.

and heard that I was returning to school and was fully committed. I was accepted to matriculate at Colby the week before school started and I embarked on a career of 200% of life—full-time student and full-time Transcendental Meditation teacher, driving to different colleges and towns in Maine five days a week while

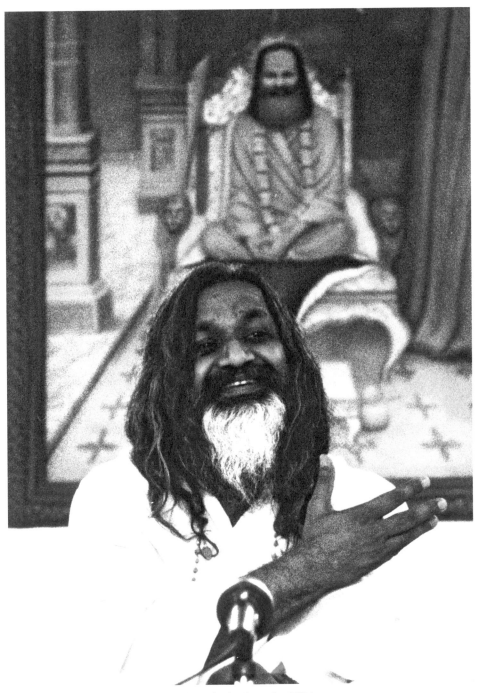
Maharishi back in the USA

never missing class and doing all the homework despite my residual study blocks. By putting myself under pressure, I was able to begin to chip away at my internal resistance. I drove to Bates College, Bowdoin College, University of Maine in Portland, Boothbay Harbor, University of Maine at Orono, and many other places

giving separate introductory and second lectures, teaching the TM technique, and returning for 3 days followup and then a 10-day meeting. It was a joyful and exciting time. I taught my first courses with and was mentored by Joe Clarke, a towering figure and dynamic person respected by all. Charlie Donahue, Jerry Jarvis and many others were inspirational and supportive. I had the good fortune to teach about 1000 people the Transcendental Meditation technique in Maine those first years.

Rick Stanley and Paul Fauerso harmonize—
The Natural Tendency band

The first year at Colby I was permitted to teach an intercession course on Transcendence in Literature. My second year, I was permitted to do a partial semester of research into TM while working on teacher training courses with Maharishi in La Antilla, Spain and Fiuggi Fonte, Italy, returning to write papers, poetry, and assemble photos. Three years later, as a senior, since I had transferred a year of credit from before Colby, I penned, then typed my Senior Scholar thesis, called *Transcendental Meditation as a Social Movement*. It took three semesters of half-time work and was a tremendous learning experience, both academically and as a writer. I wish I had distributed it more and shared it more, but it was not written or rewrit-

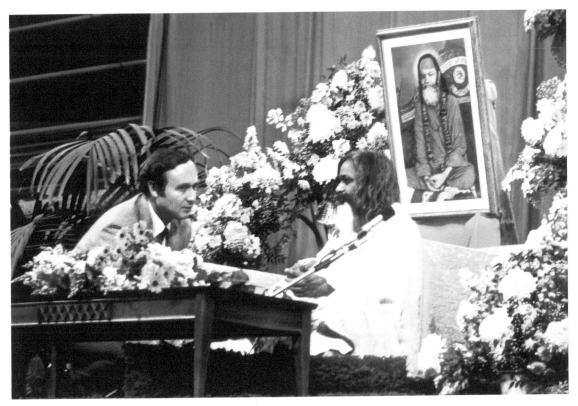

Maharishi with Jerry Jarvis

ten as a popular book. It is now on-line at the Colby College website.[*]

A fly on the wall moment: Sitting in a room near Amherst, Massachusetts, in 1971, Nat ("Internat") Goldhaber, a brilliant, dynamic man, said to Maharishi: "Let's start a university! We will buy Parson's College in Iowa. We already have faculty, and we will promote all the teachings of enlightenment in a rigorous way. Let's call it Maharishi International University. And the best part is—M. I. U. Am I you?" They both roar with laughter. Dr. Goldhaber, now a successful entrepreneur, a past candidate for V.P. of the United States on the Natural Law Party ticket, was awarded an honorary doctorate in 2013 for his numerous accomplishments by the Maharishi University of Management—M.U.M.

Another moment. While helping teach a Teacher Training Course in a resort in Majorca, Spain, during the winter of 1972, while taking a partial semester of independent credit, I was in the basement lecture hall, when it was brought to Ma-

[*] Miller, Jonathan Lewis, "Growth of transcendental meditation: a sociological study" (1973). Senior Scholar Papers. Paper 181. http://digitalcommons.colby.edu/seniorscholars/181

Maharishi, Washington, D.C.

harishi's attention that some students were discussing some matters that Maharishi had asked each student to keep quiet. Maharishi appeared at first to become very quiet. He closed his eyes. Every window and glass door in the room shattered. He said quietly in words I rather recall, "How could you do this? You have been seeking this knowledge for lifetimes." Those who were miscreants were crestfallen. Those of us observing felt the bliss of his anger, power, forgiveness.

After Colby, I taught the TM technique at the Cambridge, Massachusetts, Transcendental Meditation Center, then traveled to Switzerland and France many times for four years to be with Maharishi and take the advanced courses he was then developing: the Governor's Course and the TM-Sidhi Course; with a bit of time off living in Italy helping with the TM movement there with the friendship of dear Carla Linton Brown.

In 1977 I enrolled at the University of Washington to study physics and math. For reasons still unknown to me, I did not go to graduate school, but entered the workforce writing software first for a financial firm and then as an independent consultant. In 1985 I married and in 1989 our son was born. From 1991-1994, I

Maharishi in front of portrait of Guru Dev.
Maharishi always gives credit to Guru Dev for everything he accomplishes.

Maharishi on stage in front of portrait of Guru Dev.

studied law and passed the Colorado bar and the patent bar and entered into the practice of law.

When our son went off to college (albeit locally) I started taking college classes again. By then I had become enamored with school, having relinquished all of my study blocks since law school. I became passionate about studying the world of nature as well as enjoying it. I became immersed in the underwater world to the same degree and even more than I had with terrestrial nature. Professor Cundiff at the University of Colorado introduced me to the idea of taking courses again and permitted me to audit his upper division Marine Biology class and attend his Tropical Marine Ecology seminar in Cozumel. I was hooked. The professors at CU welcomed me into their classes, allowed me to study biology, mathematics (environmental mathematics!), oceanography, primate anthropology, natural resource law, environmental policy, environmental ethics and environmental journalism. I figured if I wanted to change the world, then I needed to understand it, including invertebrate zoology, parasites, insects, and so much more. As things last stood, I

140

His Holiness Maharishi Mahesh Yogi

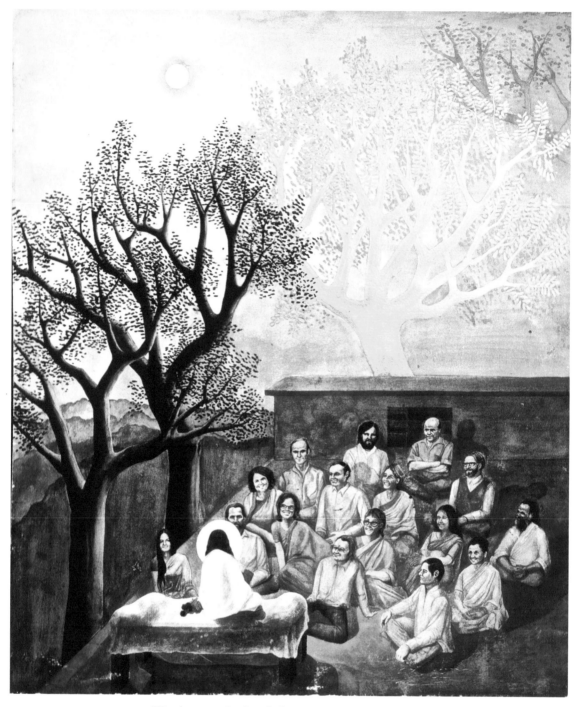

"Teaching on the Roof" by artist Dr. Susan Shumsky
Rishikesh, 1970

had completed a certificate in environmental policy and achieved (and loved) being a teaching assistant (TA) for Professor Cundiff's introductory biology course.

It is hard for me to express the depth of my admiration and gratitude I feel to these generous men and women who have devoted their lives to study and inquiry,

and who share their deep wisdom and knowledge generously with others. They too are seers.

I believe that if we want to protect the planet from humans, then humans at the most fundamental level must expand their consciousness to be all encompassing, compassionate, and naturally aware of consequences of actions. Practice TM. Be fulfilled, act in accordance with the Laws of Nature and enjoy.

I traveled to India in 1970 when I was two times eleven in years (2x11) and now after two-squared eleven (2^2x11) years, at age two-times-three times 11 (2x3x11), I am writing and compiling this book. I hope that it brings you, gentle reader, pleasure.

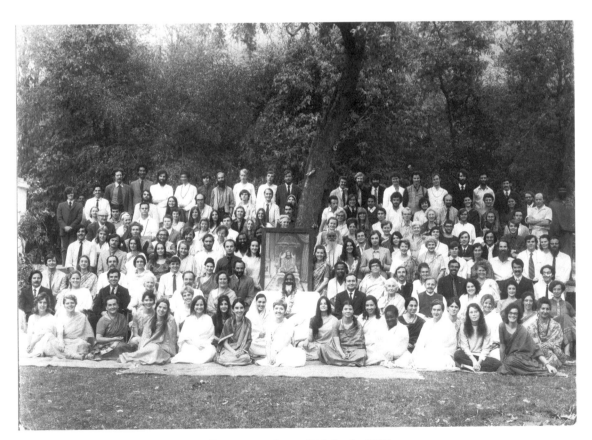

Our course photo, Rishikesh, 1970

The author and his wife revisit India in 2014

JONATHAN MILLER

Jonathan Miller began the practice of the Transcendental Meditation® (TM®) technique in 1968 and traveled to India in 1970 to attend Maharishi Mahesh Yogi's last teacher training course for Westerners that was held in India. Later, he was directed to go back to school. He first majored in sociology, teaching TM to about 1000 students, faculty and and the public in Maine. Later he earned degrees in physics, law, and studied environmental policy, biology, mathematics and other fields. While practicing law and mediation, he became a ski and scuba instructor, and practiced aikido. Committed to nature and the environment, he is working on travel and nature books and movies.

"The greatest changes to individuals and the world come from the changes in consciousness brought about by the regular practice of Transcendental Meditation, and we also have to do everything we can to protect the environment, educate our children, and nurture our planet."